IRELAND
GLORIOUS LANDSCAPES

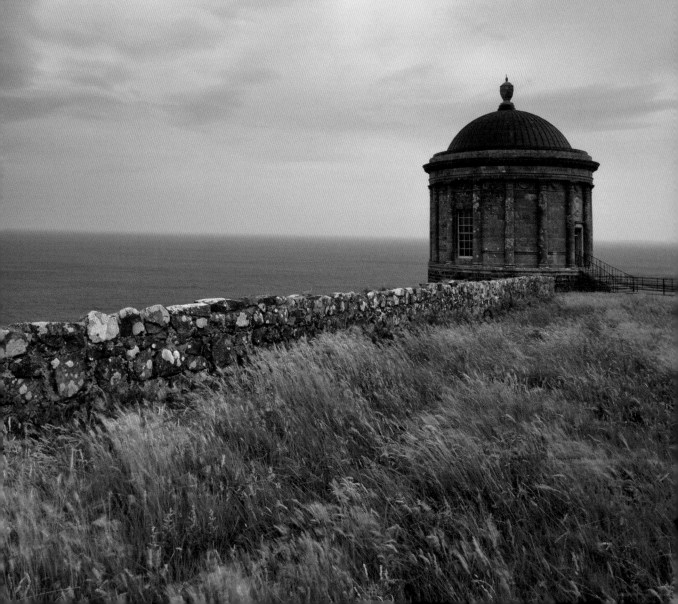

CARSTEN KRIEGER'S unique images of the Irish landscape are highly acclaimed and he is the author of several books of landscape photography. His photographs have been published in magazines and calendars and he also exhibits in Ireland and abroad on a regular basis. His website, Carsten Krieger photography, is at www.carstenkrieger.co.uk.

PETER HARBISON is an archaeologist, writer, lecturer, former editor of Bord Fáilte's *Ireland of the Welcomes* magazine and author of many books about Ireland. He is the Honorary Academic Editor at the Royal Irish Academy, Professor of Archaeology at the Royal Hibernian Academy of Arts, Honorary Fellow of Trinity College, Dublin, and a Fellow of the Society of Antiquaries of London.

MURIEL BOLGER, who has written the regional introductions for this book, is an experienced travel writer and magazine editor.

IRELAND
GLORIOUS LANDSCAPES

OVER 200 BEAUTIFUL VIEWS

CARSTEN KRIEGER

introduction by Peter Harbison

THE O'BRIEN PRESS
DUBLIN

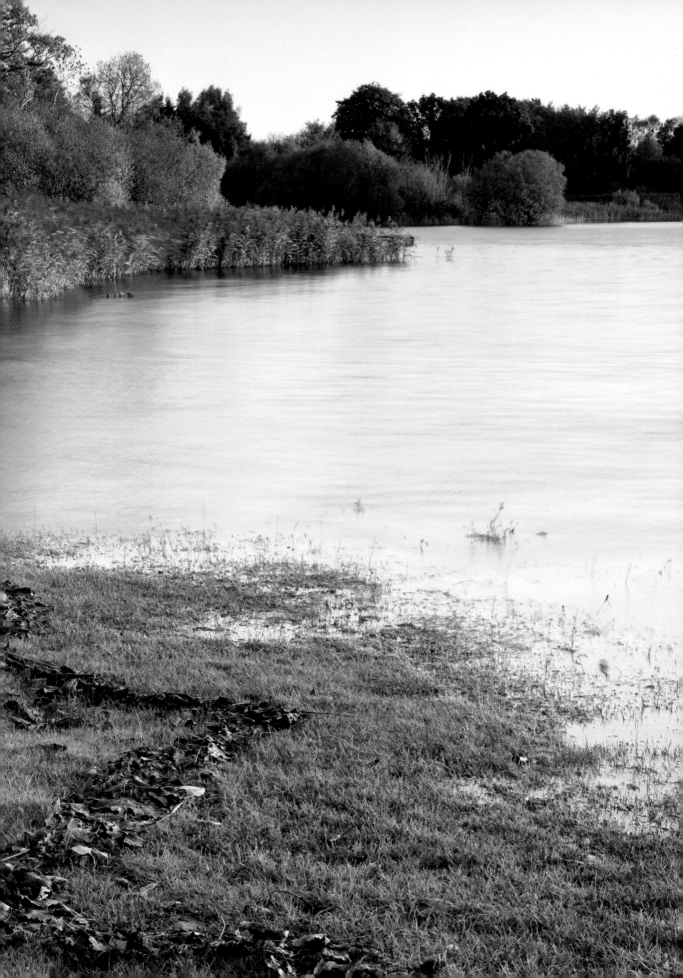

CONTENTS:

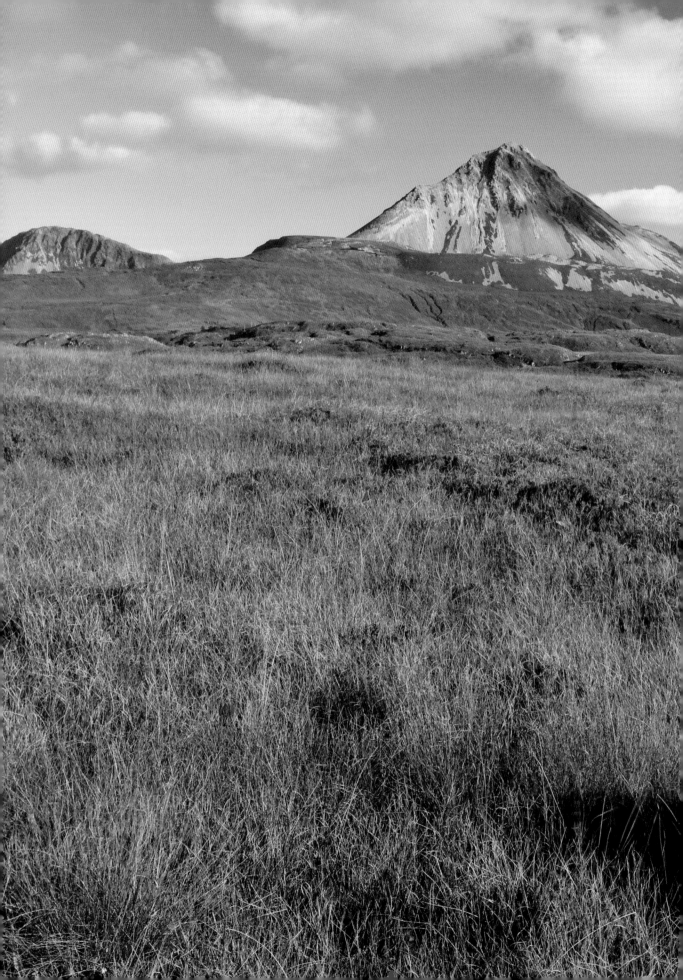

INTRODUCTION
BY PETER HARBISON

We, the Irish, often fail to realise what a beautiful country we live in, simply because we have it all around us and take it too much for granted. Far off hills are green, it is often said – but so also are the ones nearer home. We really need an outsider to show us how to look at and appreciate our own surroundings through new eyes or, in the case of Carsten Krieger, through an imaginatively-focused lens. He stands in a long line of Germans who have been beguiled by Ireland, its people and colourfully-changing moods, and who feel the poetic lyricism of the landscape and its varied constituents.

The Ireland Krieger presents to us is not that of the perpetual blue skies beloved of tourist brochures. Instead, we have an exotic variety of clouds, scudding wispily across the heavens like fluffy cotton wool, or brooding melancholically, hovering threateningly and allowing us to understand how the only fear of the ancient Celts was that the sky would fall down upon them. He has managed to capture the mystic early morning mood or evening stillness on lake and seashore, leading us into a secret world where – if we could but

discover where exactly he stood to take his photographs – we could commune alone and in perfect peace with the majesty of creation. Recent intrusions in all the country's provinces are largely kept at bay, and much of the human activity visible is that of earlier centuries, where ancient monuments from dolmens to castles and churches pepper and punctuate the pages otherwise devoted to nature. Sometimes, that nature is gentle, almost sublime, at other times eerie, verging on the surreal, with occasional trees dancing singly or together like ghosts in Elysian fields, or joining together to form an entrancing gothic archway.

But the real essence and charm of this photo collection is water, be it rushing down in mountainous cascades, standing still in an inland lake, or fascinating the eye on an isolated beach – a half-way house between land and sea. Here the artist's eye comes into play, offering us an abstract painting or

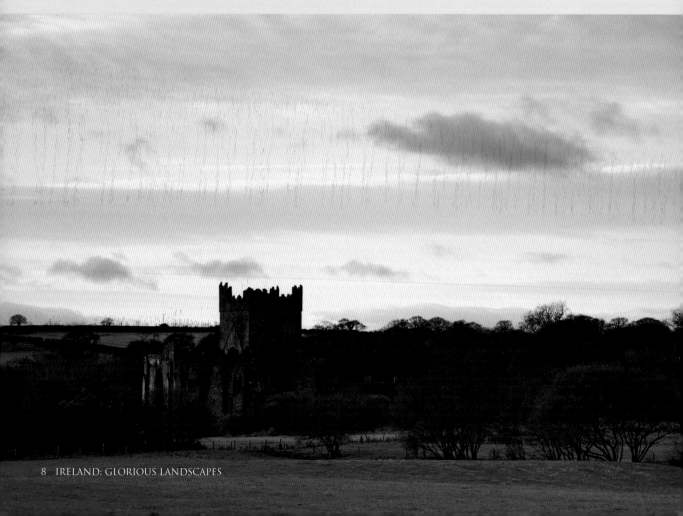

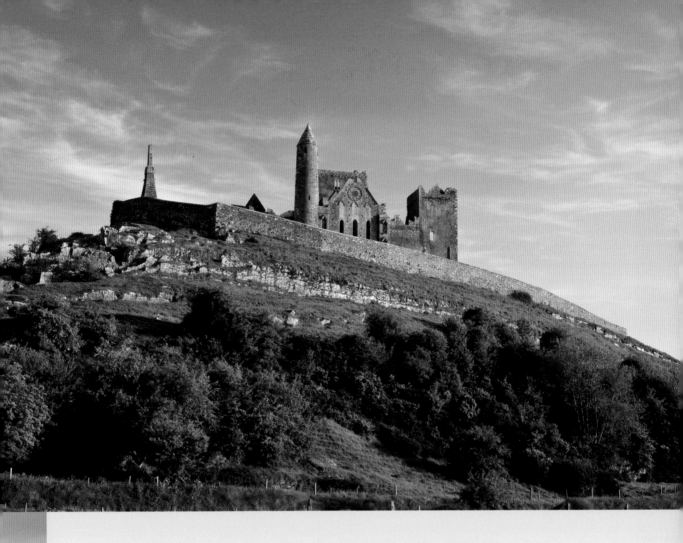

a panorama where heaven and earth fuse majestically in a symphony of colour. An accompanying constituent is stone, as seen in the ancient monuments, or in the karst limestone scenery of the Burren or the Aran Islands, where its patina of age has managed to blend in so superbly with the green of the grass on level plains, or among the rugged glacial valleys and the imposing vastness of the hills.

Even if a photographer like Carsten Krieger may have to wait for the light to be just right, he has the advantage over the watercolourist of being able to just press a button to immortalise a moment, whereas the painter can often be frustrated by the fast-changing hues of the magical Irish landscape evaporating in front of his eyes before he can document them with his brush. So, let us celebrate the photographer's triumph in capturing wonderful insights into an almost untouched world which needs recording before it may change in undesirable ways we may not wish to contemplate.

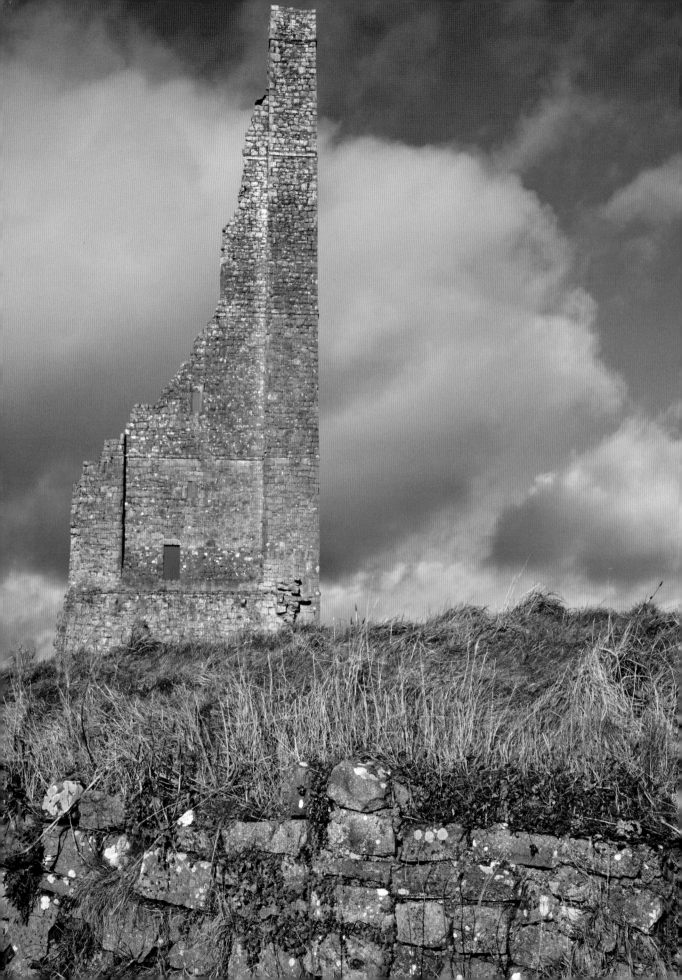

THE
EAST

History, lore and legend are woven together in the fabric of the Irish landscape. The East of Ireland captures many of its moods and aspects, from the atmospheric sunrises over the Irish Sea to the ever-changing skyscapes above the Bog of Allen, where much of the peat for the famous Irish turf fires was harvested.

The Neolithic burial ground at Newgrange, which pre-dates the pyramids in Egypt, is an intriguing place; visitors can wonder at the knowledge of its builders, whose skills allowed them to build a tomb where the sun's rays reach the inner chamber only once a year, at sunrise on the dawn of the winter solstice on 21 or 22 December. The Hill of Slane is closely associated with the dawning of Christianity in this island and with Saint Patrick, Ireland's patron saint.

Further south, evidence of the early Christian past has its own record in the sixth-century monastic settlements at Glendalough in Co. Wicklow. Glendalough is home to one of Ireland's best-preserved round towers, while this and other graveyards hold many secrets beneath the lichen-covered headstones and symbolic Celtic crosses.

Opposite left: St Mary's Church, Trim, Co. Meath.

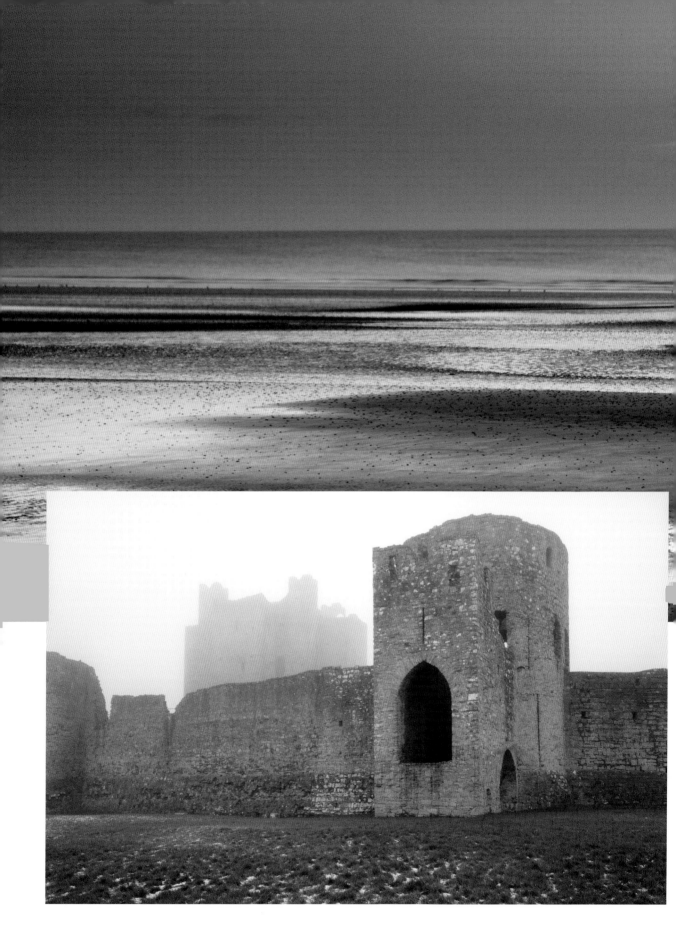

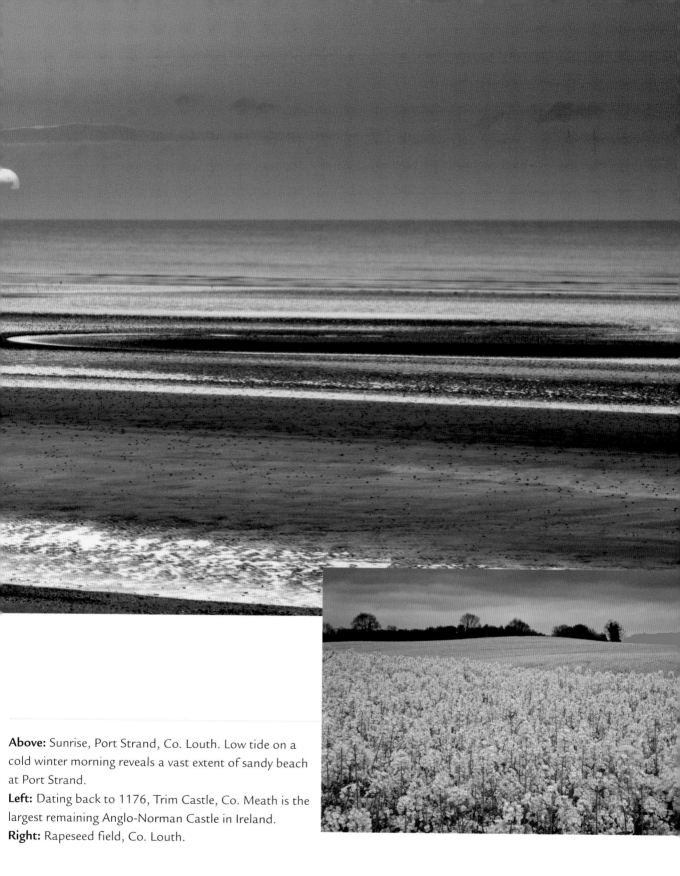

Above: Sunrise, Port Strand, Co. Louth. Low tide on a cold winter morning reveals a vast extent of sandy beach at Port Strand.
Left: Dating back to 1176, Trim Castle, Co. Meath is the largest remaining Anglo-Norman Castle in Ireland.
Right: Rapeseed field, Co. Louth.

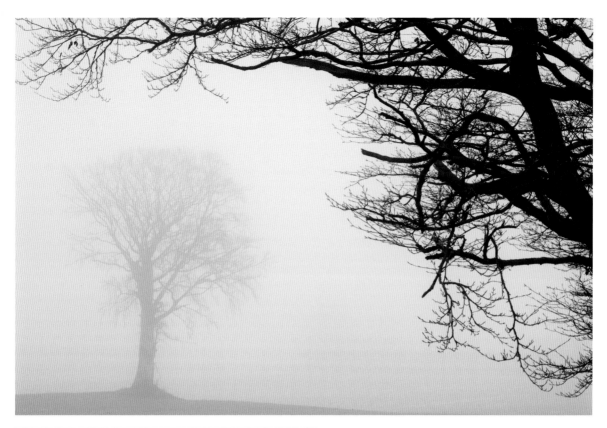

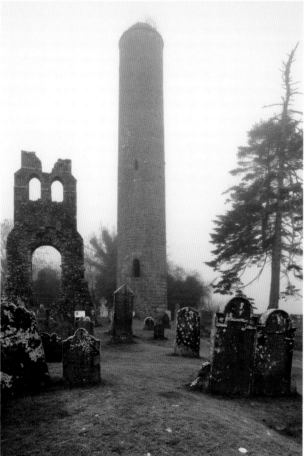

Above: Tree and fog, near Donore, Co. Meath.
Left: Donaghmore Church, Co. Meath (of which only one wall remains) was built hundreds of years later than the round tower.
Opposite: The Muiredach High Cross at Monasterboice Abbey, Co. Louth (named after an abbot, Muiredach mac Domhnaill, who died in 923) is decorated with biblical carvings of both the Old and New Testaments. The monastic settlement at Monasterboice was founded in the 5th century and was an important religious centre until 1142 when the nearby Mellifont Abbey was founded.

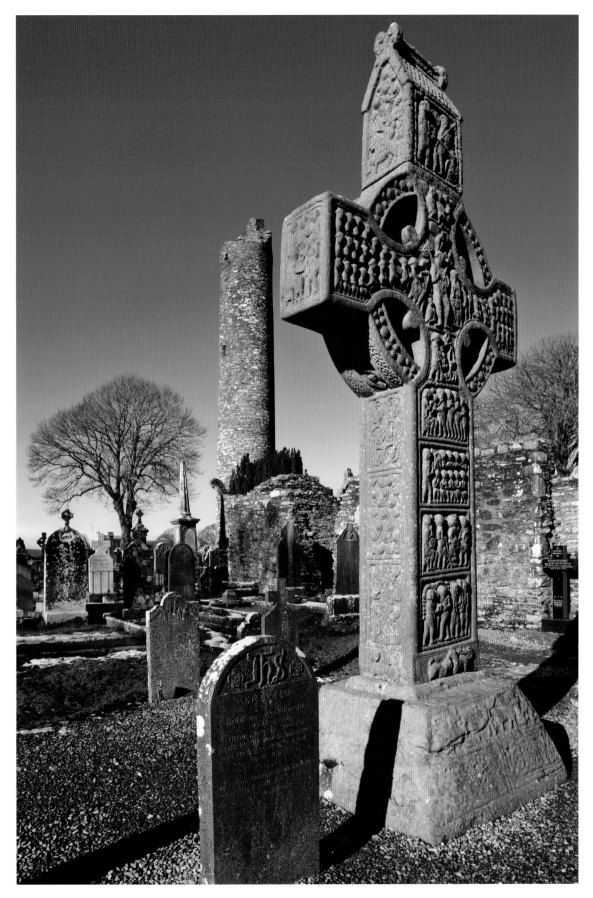

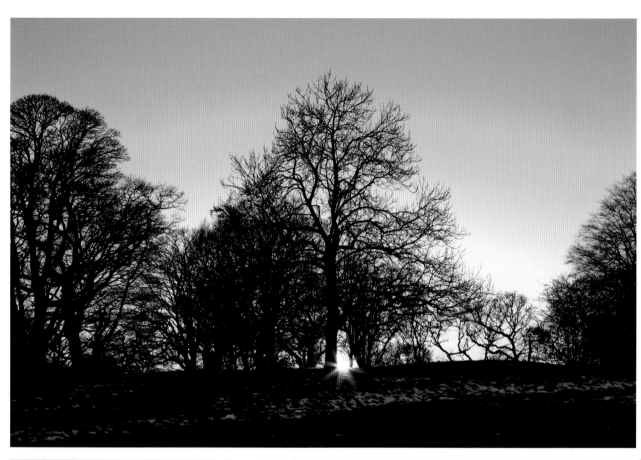

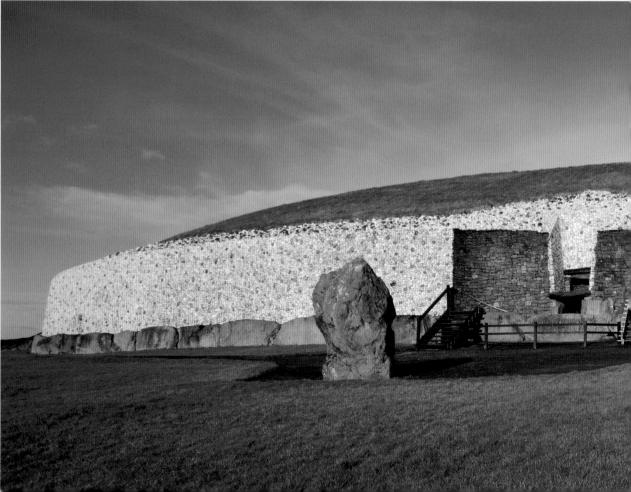

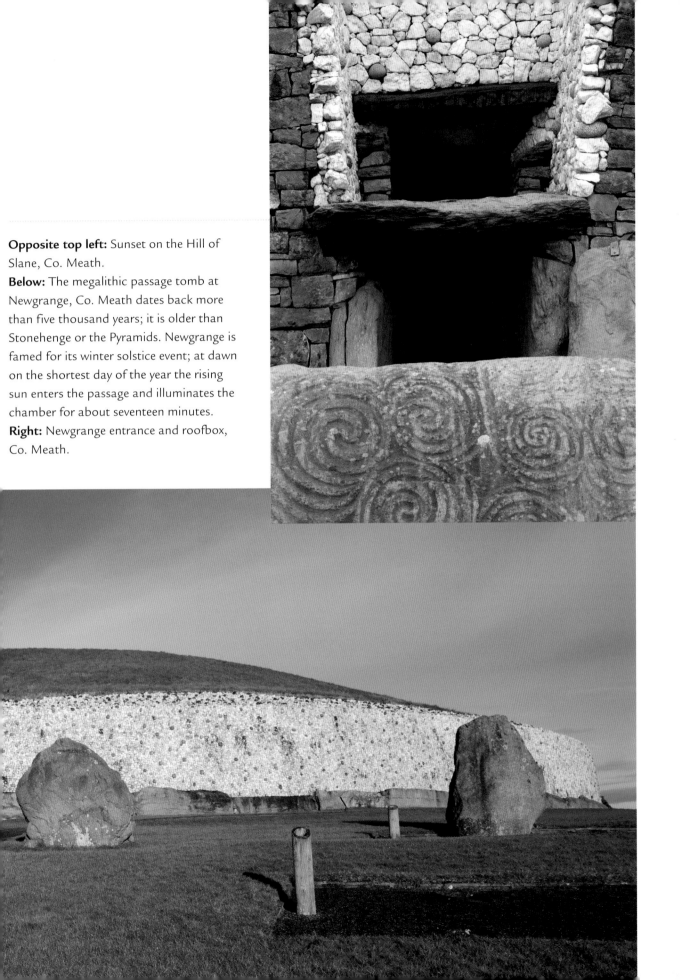

Opposite top left: Sunset on the Hill of Slane, Co. Meath.

Below: The megalithic passage tomb at Newgrange, Co. Meath dates back more than five thousand years; it is older than Stonehenge or the Pyramids. Newgrange is famed for its winter solstice event; at dawn on the shortest day of the year the rising sun enters the passage and illuminates the chamber for about seventeen minutes.

Right: Newgrange entrance and roofbox, Co. Meath.

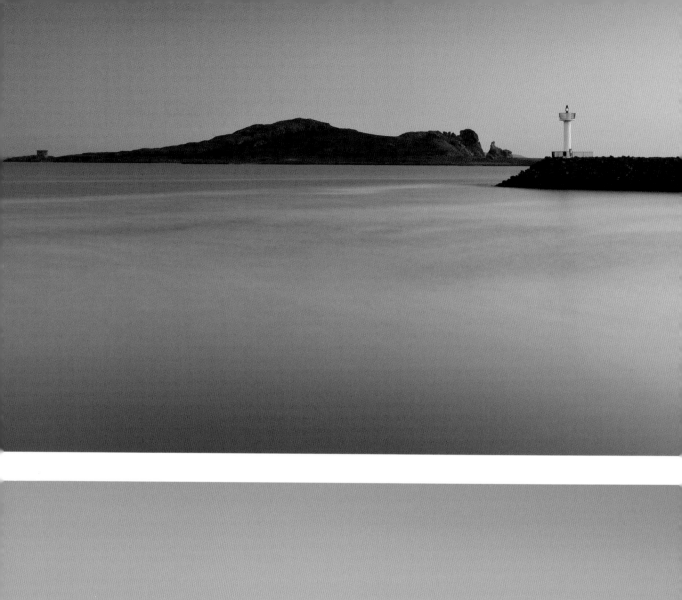

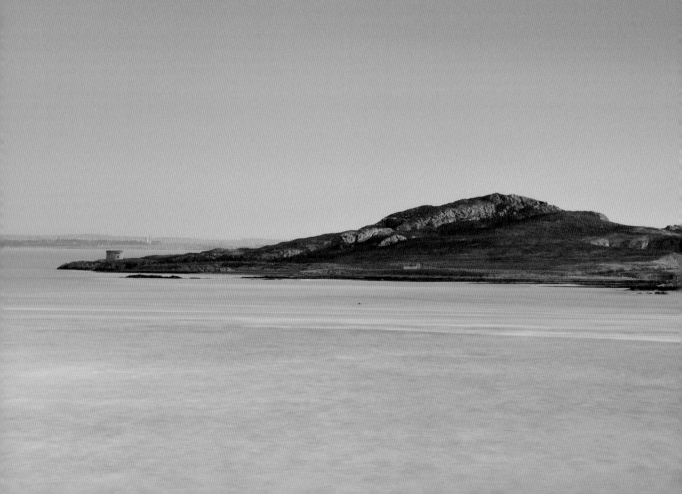

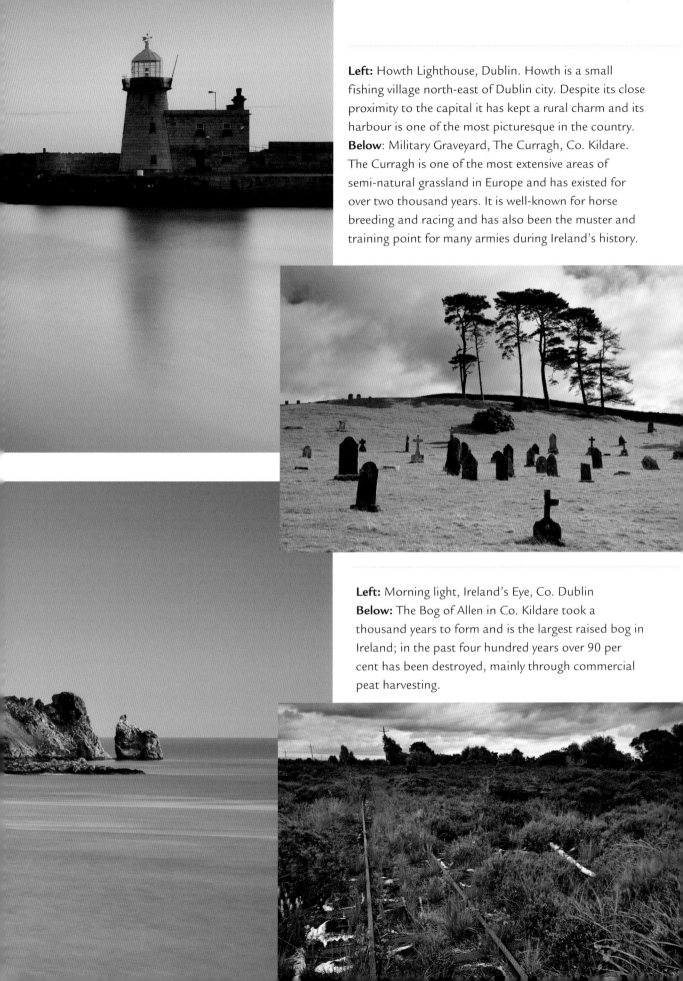

Left: Howth Lighthouse, Dublin. Howth is a small fishing village north-east of Dublin city. Despite its close proximity to the capital it has kept a rural charm and its harbour is one of the most picturesque in the country.
Below: Military Graveyard, The Curragh, Co. Kildare. The Curragh is one of the most extensive areas of semi-natural grassland in Europe and has existed for over two thousand years. It is well-known for horse breeding and racing and has also been the muster and training point for many armies during Ireland's history.

Left: Morning light, Ireland's Eye, Co. Dublin
Below: The Bog of Allen in Co. Kildare took a thousand years to form and is the largest raised bog in Ireland; in the past four hundred years over 90 per cent has been destroyed, mainly through commercial peat harvesting.

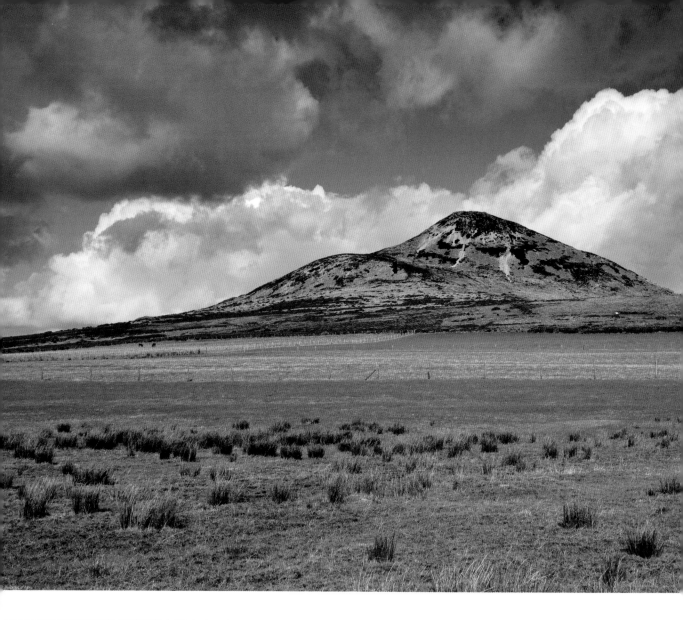

Above: Great Sugar Loaf Mountain, Co. Wicklow.
Opposite top: Reflection in the Upper Lake, Glendalough, Co. Wicklow.
Opposite bottom: Snow on the Wicklow Mountains near the Wicklow Gap, Co. Wicklow.

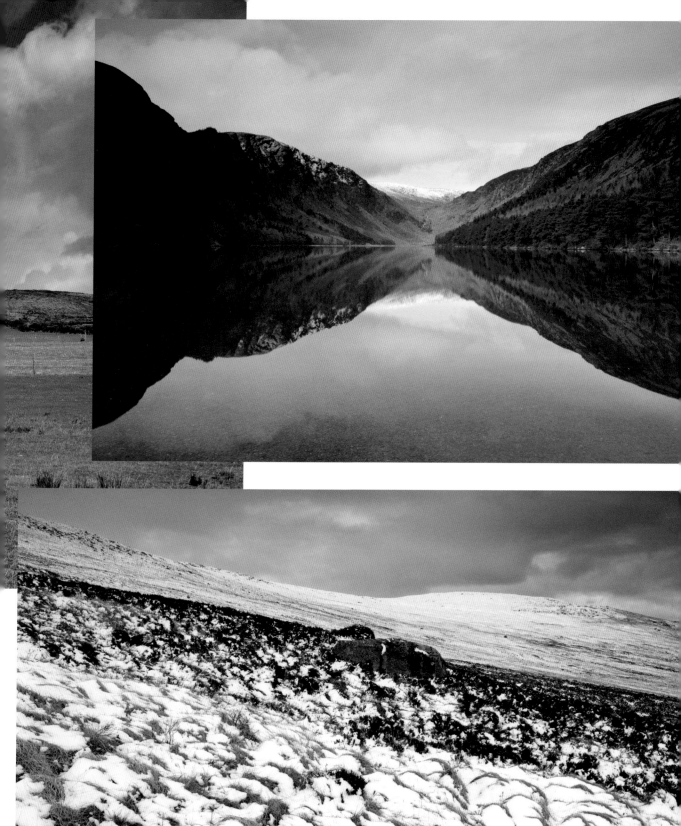

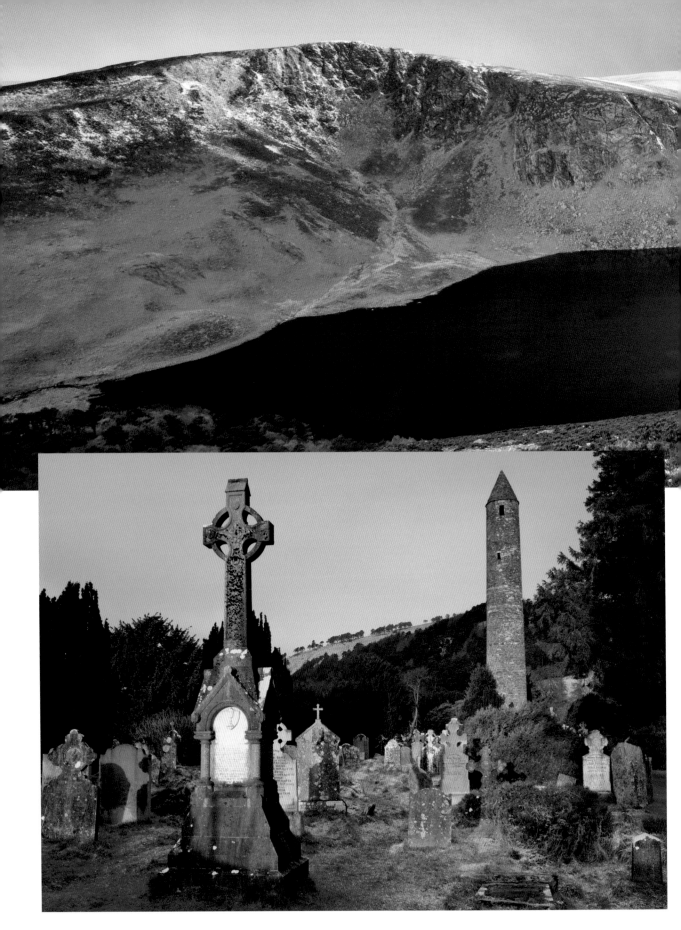

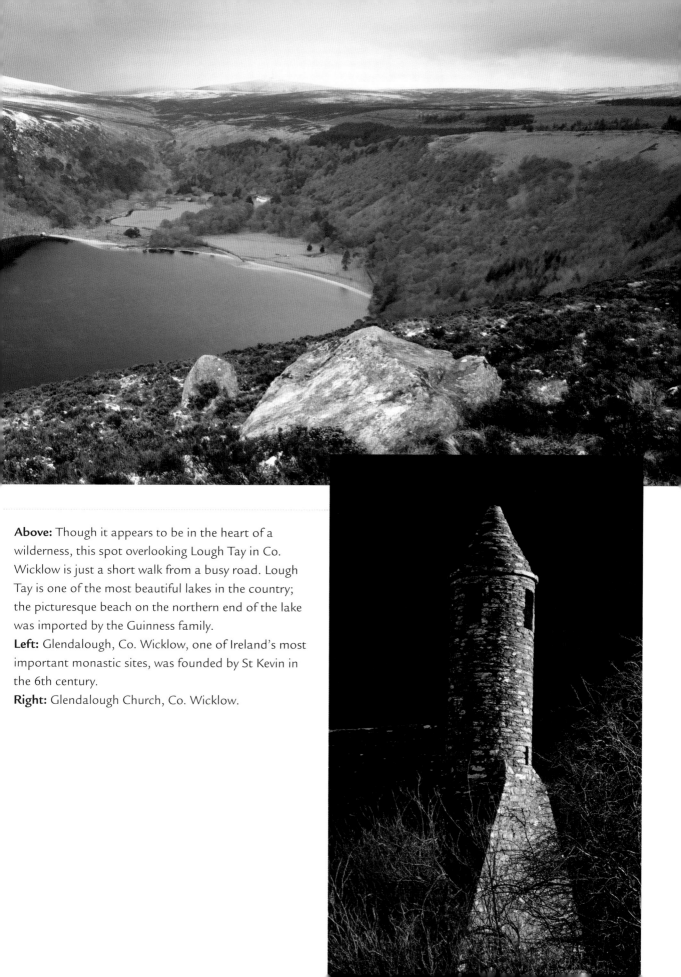

Above: Though it appears to be in the heart of a wilderness, this spot overlooking Lough Tay in Co. Wicklow is just a short walk from a busy road. Lough Tay is one of the most beautiful lakes in the country; the picturesque beach on the northern end of the lake was imported by the Guinness family.

Left: Glendalough, Co. Wicklow, one of Ireland's most important monastic sites, was founded by St Kevin in the 6th century.

Right: Glendalough Church, Co. Wicklow.

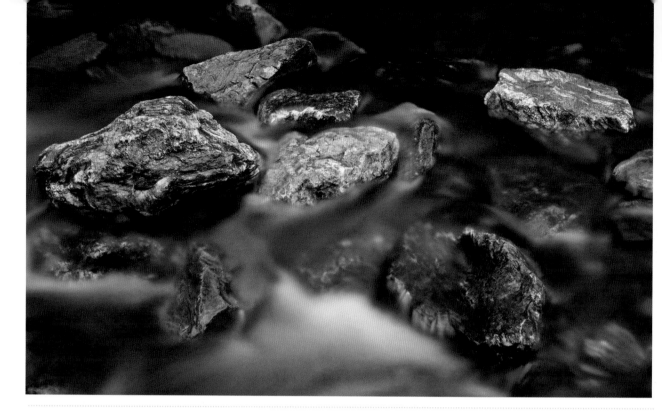

Above: Glencree River, Co. Wicklow.
Below: Glenmacnass Waterfall, Co. Wicklow.

Opposite right: At 121 metres, Powerscourt Waterfall, part of the Powerscourt Estate in Co. Wicklow, is the highest in Ireland.

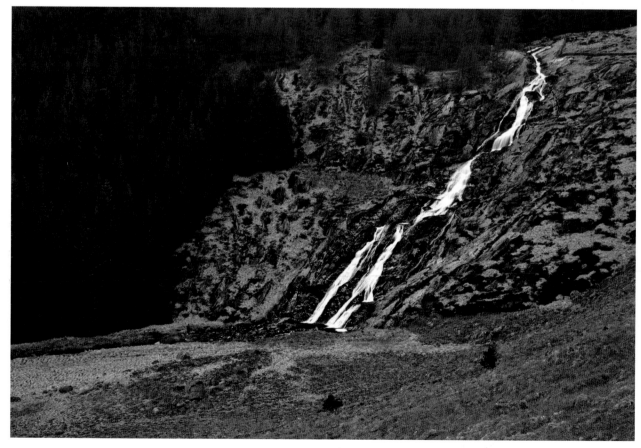

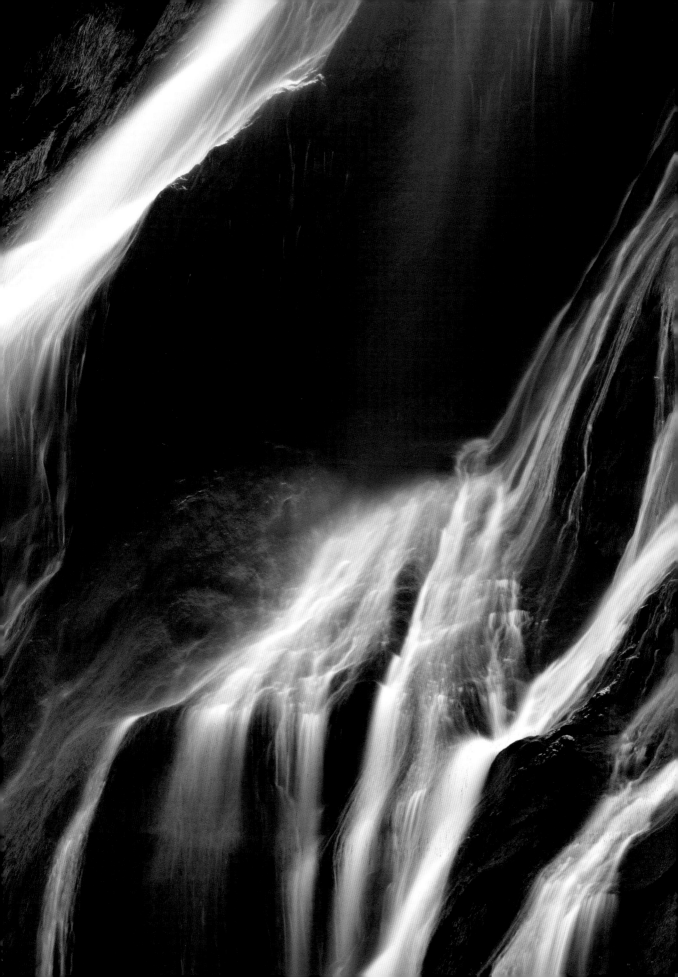

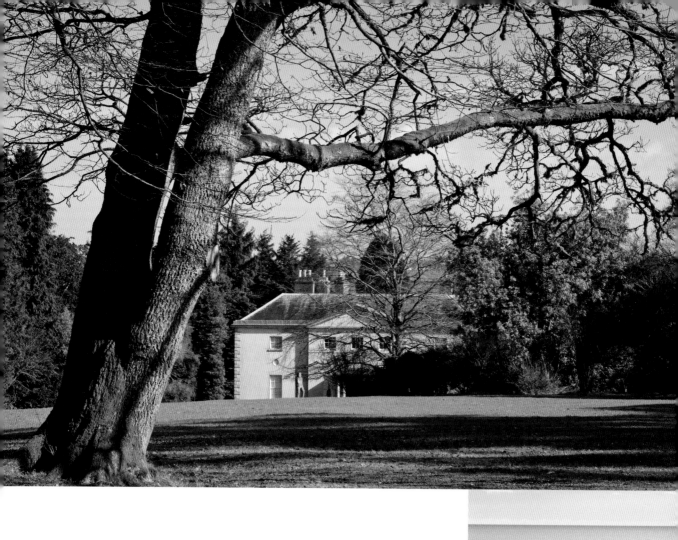

Above: Avondale House & Forest Park, Co. Wicklow.
Opposite right: Leamore Strand,
Co. Wicklow.

Right: Brittas Bay, Co. Wicklow, with its sandy beach and dunes, is the most popular seaside resort for Dubliners to retreat to on a warm summer's day. The word 'Brittas' is of French origin – 'bretesche' meaning 'boarding' or 'planking' – and refers to a castle mound from the Anglo-Norman period.

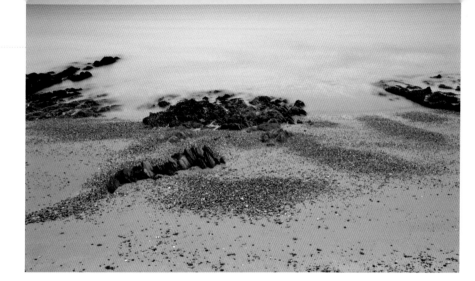

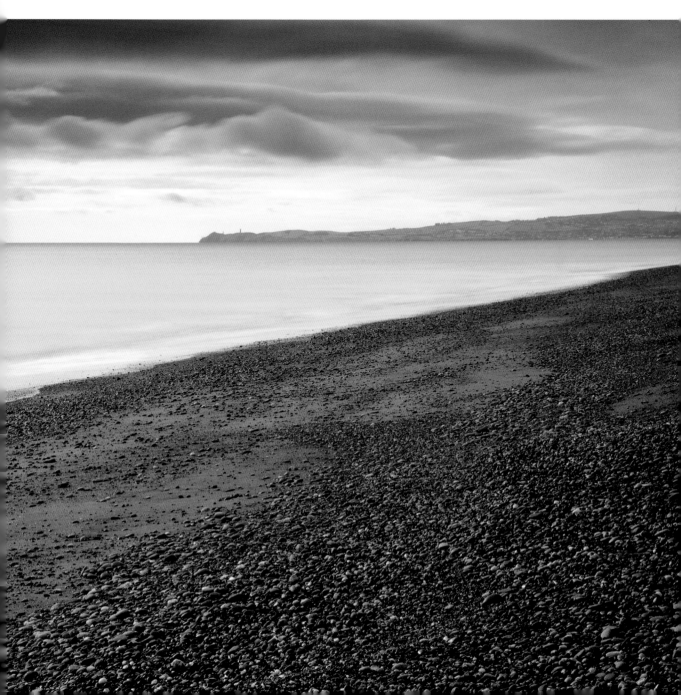

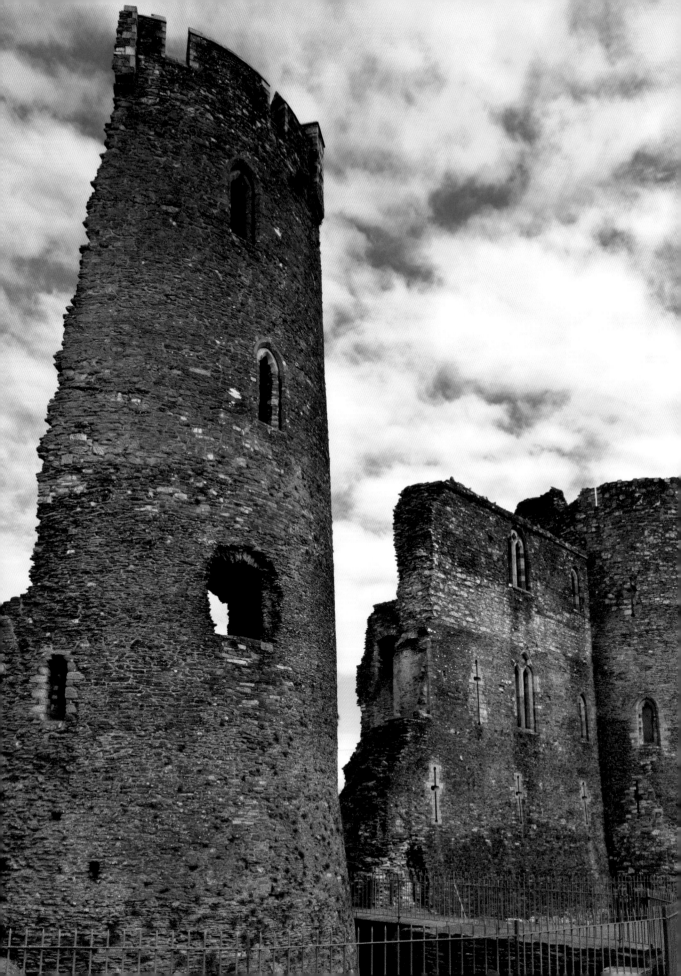

THE SOUTH EAST

This region is often described as Ireland's 'sunny South East' because it has more hours of sunshine than anywhere else in the country. Its coastline is dotted with superb beaches and little fishing villages, rocky headlands, copper-stained cliffs and coves.

The Comeragh Mountains reward climbers with unspoiled panoramic views across the rolling countryside. The region is fed by the sister rivers, the Barrow, the Nore and the Suir.

In former days, the area was heavily defended against possible attacks from the Vikings, the Normans, Napoleon, and others; consequently there are lots of fortresses and remains of old castles and grand houses to be found throughout.

When you look at Ireland's ruins it's easy to see why it was called 'the island of saints and scholars', for nowhere are you far from a seat of learning. The Cistercian monks had two very impressive monasteries in this area, one at Jerpoint in Co. Kilkenny and the second in Tintern. Tintern Abbey and the Augustinian Selskar Abbey lie in ruins in Co. Wexford. A more contemporary model is the Edmund Rice Heritage Centre in Waterford, detailing the history of the Irish Christian Brothers.

Left: Ferns Castle, Co. Wexford, like Tintern Abbey was built in the thirteenth century by William Marshall; it was destroyed in 1649 by Cromwell.

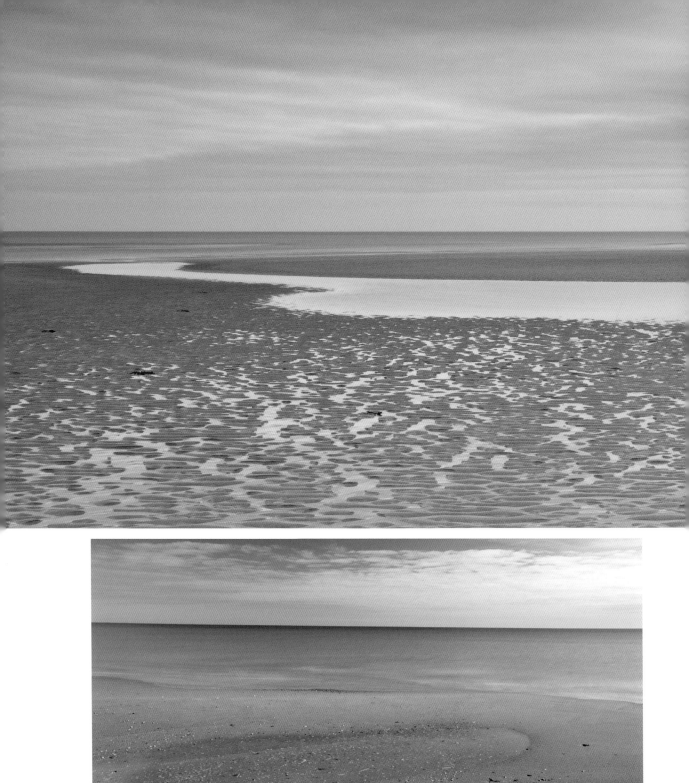

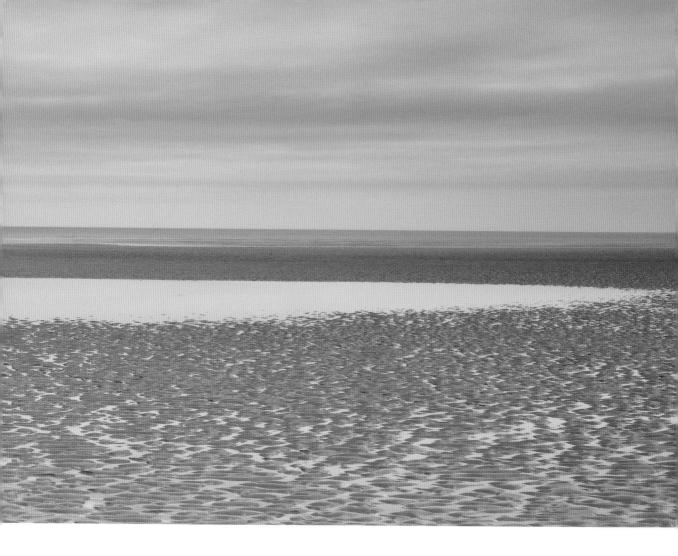

Above: Tidal pool, Grange Strand, Co. Wexford.
Right: The Raven Nature Reserve in Co. Wexford is a major sand dune system adjacent to a small semi-natural woodland. The area is of huge ecological importance as 35 per cent of the world's population of Greenland White-Fronted Geese spend the winter here. They feed in the nearby Wexford Wildfowl Reserve during the day and spend the night in the shelter of the Raven dune system.
Left: Shells & strand, The Raven, Co. Wexford.

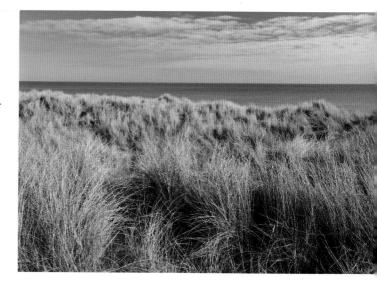

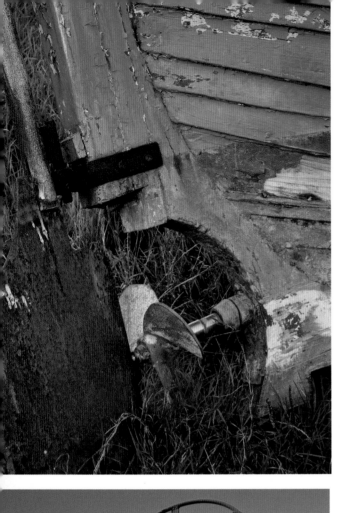

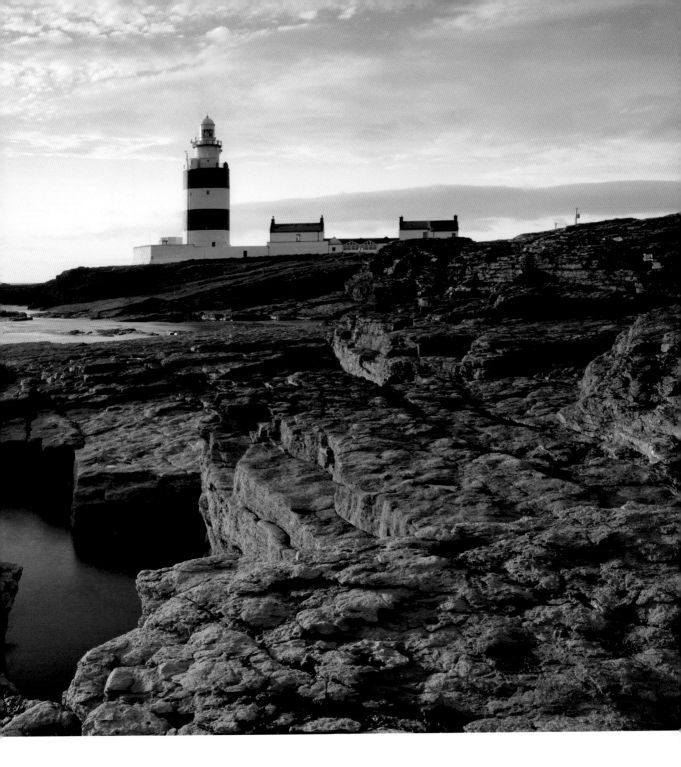

Opposite top and bottom: Boat detail, Arthurstown,
Co. Wexford.
Above: Hook Lighthouse, Co. Wexford is thought to be
one of the oldest still operational in the world having
served sailors for around eight hundred years.

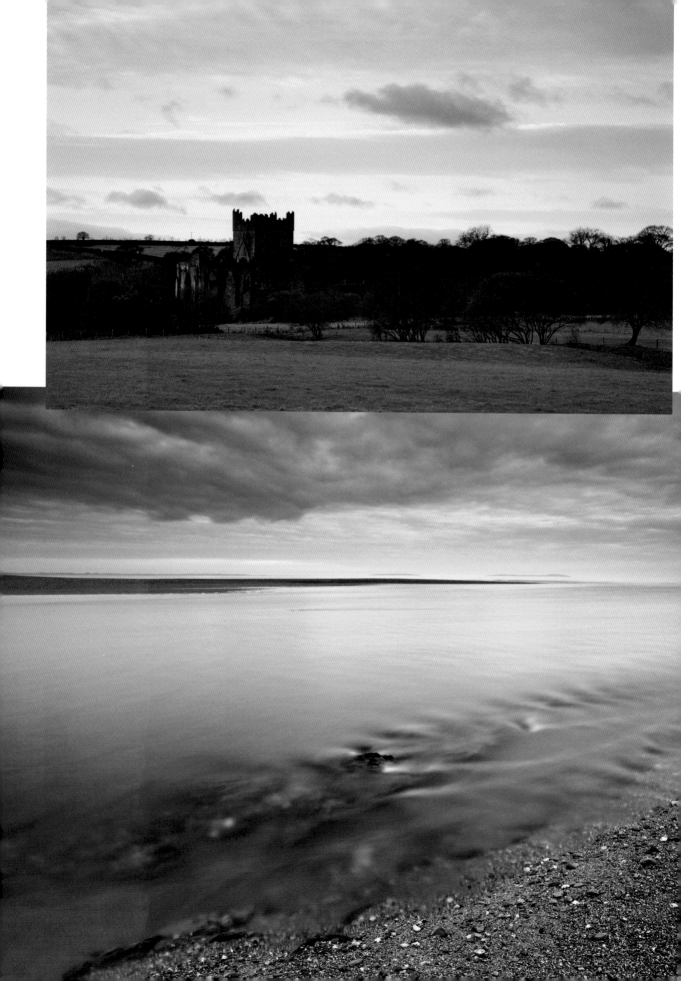

Left: Tintern Abbey, Co. Wexford, seen here on a winter morning, was founded by William Marshal, Earl of Pembroke and Lord of Leinster. On his first journey to Ireland he was threatened with shipwreck and made a vow to found an abbey wherever he made safe landfall. He redeemed his vow and made Tintern Abbey, sometimes called '*Tintern de Voto*' ('Tintern of the vow') into one of the richest Cistercian Abbeys in Ireland.

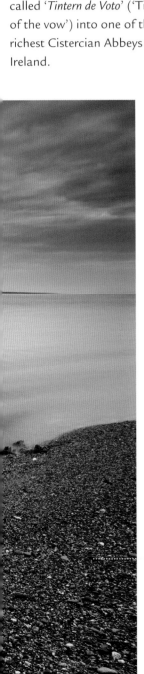

Above: Trees on the Hook Peninsula, Co. Wexford.
Left: Cullenstown Strand, Ballyteige Bay, Co. Wexford.

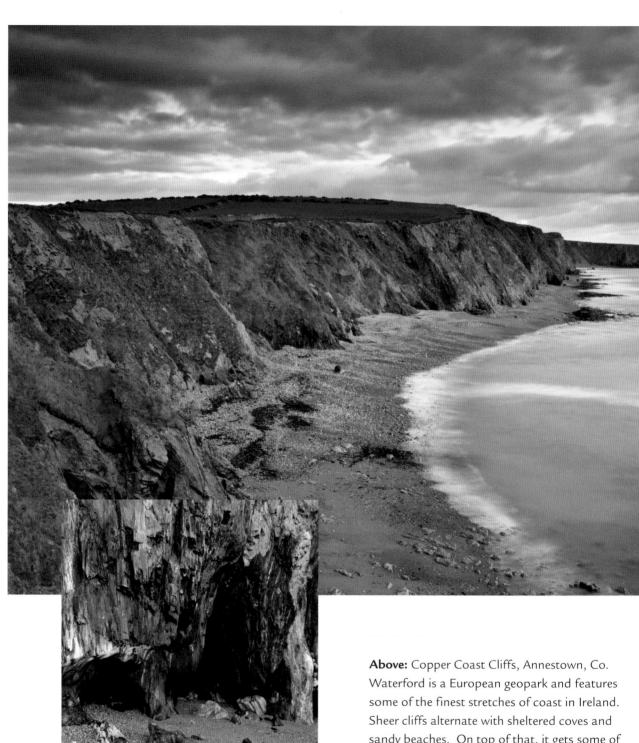

Above: Copper Coast Cliffs, Annestown, Co. Waterford is a European geopark and features some of the finest stretches of coast in Ireland. Sheer cliffs alternate with sheltered coves and sandy beaches. On top of that, it gets some of the best weather in Ireland!

Left: Cliff & pebble strand, Ballyvooney Cove, Co. Waterford.

Opposite top: Sunset, Bunmahon beach, Co. Waterford.

Opposite bottom: Copper Mine, Co. Waterford

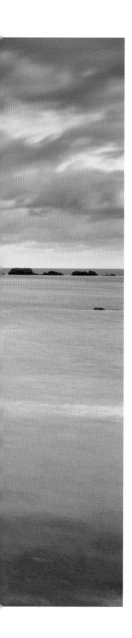

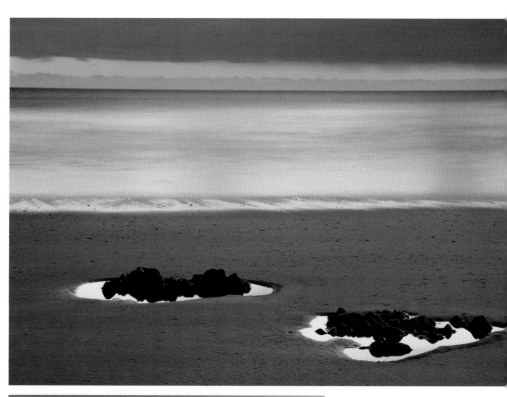

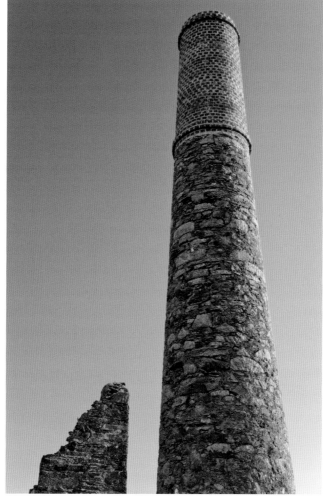

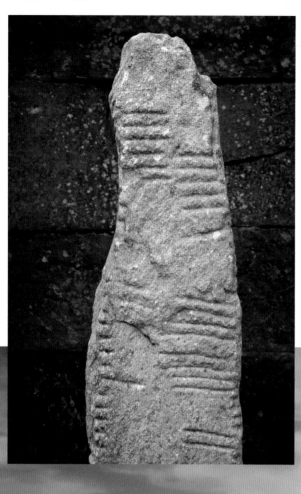

Left: Ogham stone, Ardmore, Co. Waterford; Ogham is an early medieval alphabet representing mainly the old Irish language.

Opposite top: Ardmore Church, Co. Waterford. The monastic site at Ardmore is thought to have been founded in the 5th century by St Declan, which would make the site one of the oldest in Ireland, predating St Patrick. However, the cathedral and round tower for which Ardmore became famous weren't built until the 12th century.

Below: Clonea Bay, Co. Waterford.

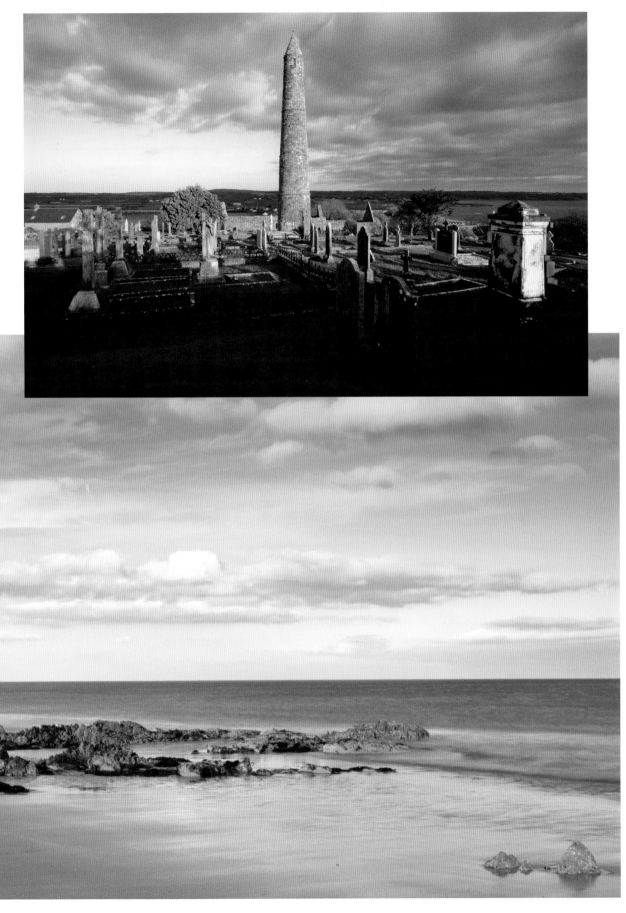

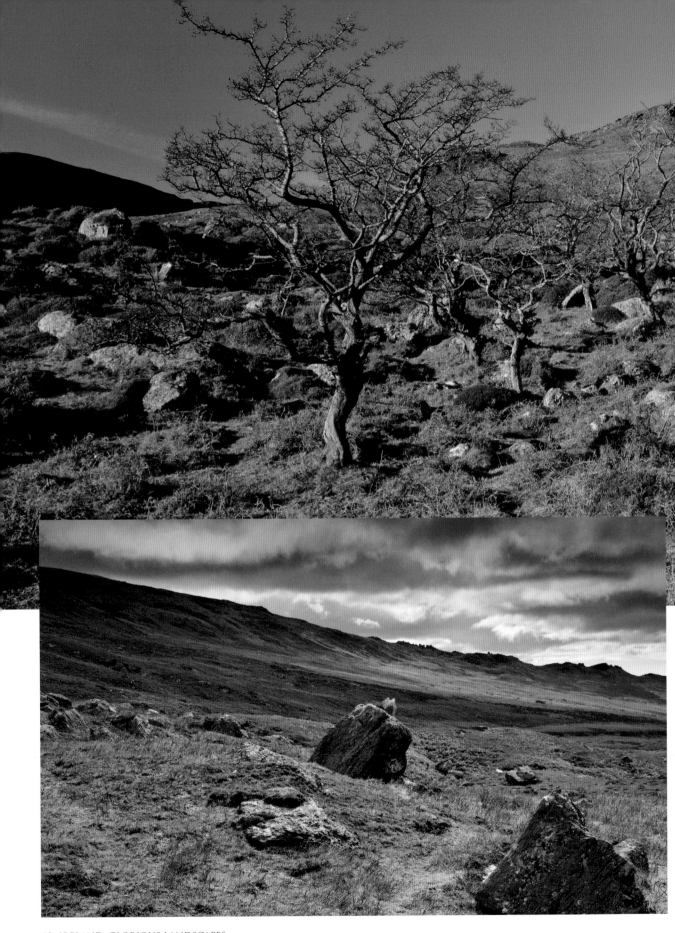

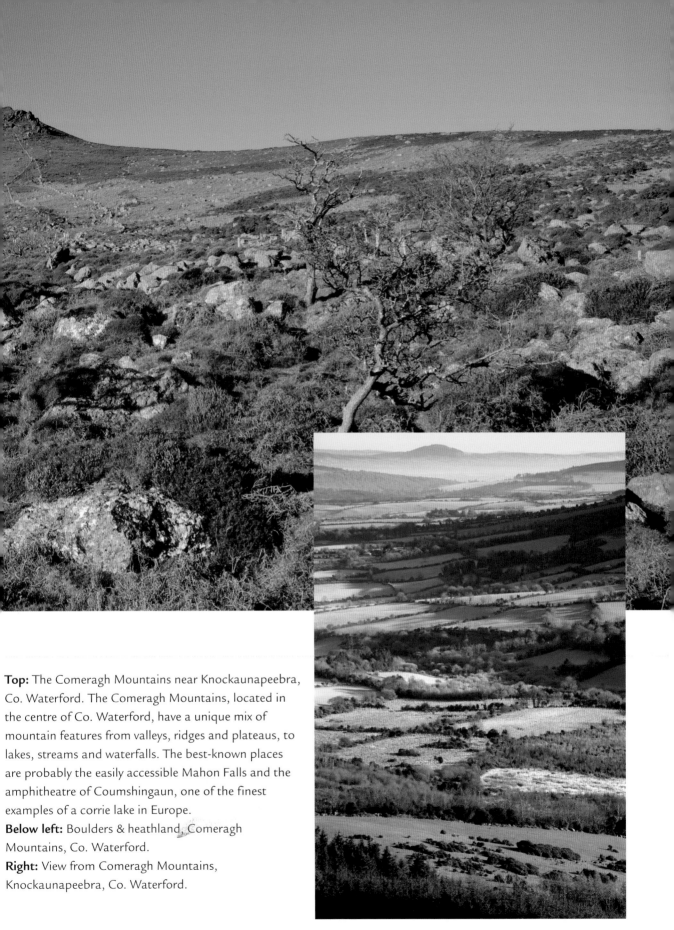

Top: The Comeragh Mountains near Knockaunapeebra, Co. Waterford. The Comeragh Mountains, located in the centre of Co. Waterford, have a unique mix of mountain features from valleys, ridges and plateaus, to lakes, streams and waterfalls. The best-known places are probably the easily accessible Mahon Falls and the amphitheatre of Coumshingaun, one of the finest examples of a corrie lake in Europe.
Below left: Boulders & heathland, Comeragh Mountains, Co. Waterford.
Right: View from Comeragh Mountains, Knockaunapeebra, Co. Waterford.

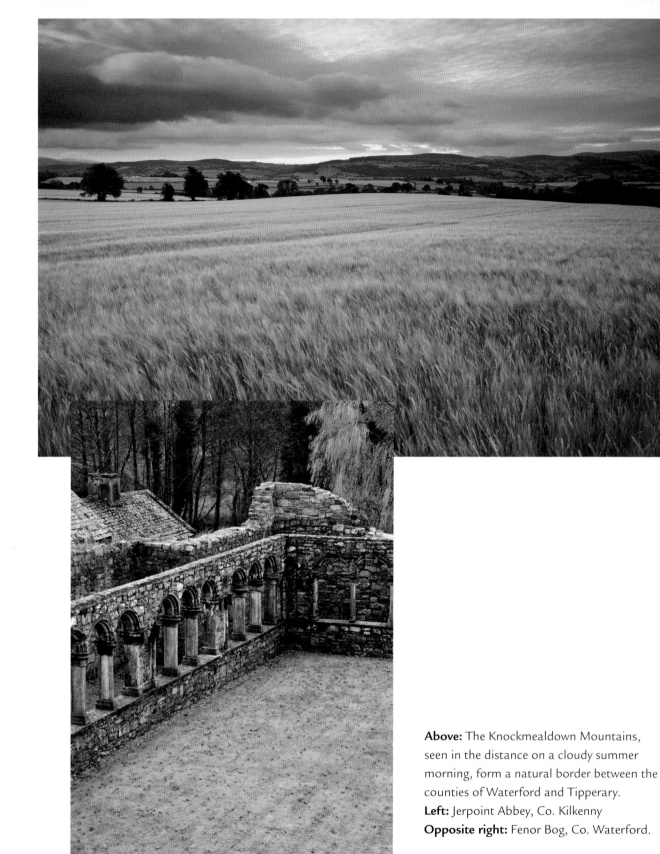

Above: The Knockmealdown Mountains, seen in the distance on a cloudy summer morning, form a natural border between the counties of Waterford and Tipperary.
Left: Jerpoint Abbey, Co. Kilkenny
Opposite right: Fenor Bog, Co. Waterford.

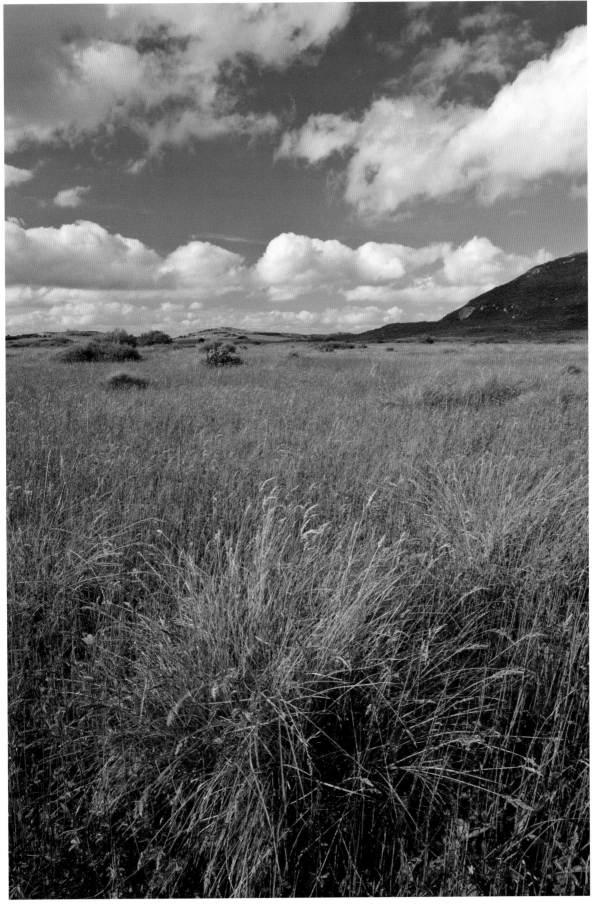

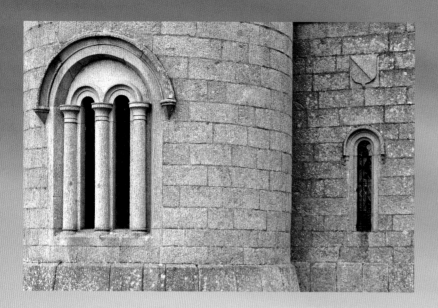

Main pic: Tree & field, near Tullow, Co. Carlow.
Inset Above: Duckett's Grove, Co. Carlow, now in ruins, is a former mansion, originally built around 1745 and transformed into a gothic fairytale castle in the 19th century by Thomas Cobden.
Inset opposite: Brown's Hill Dolmen, Co. Carlow portal tomb was built two to three thousand years ago and has probably the heaviest capstone recorded in Europe, weighing an estimated 100 metric tonnes.

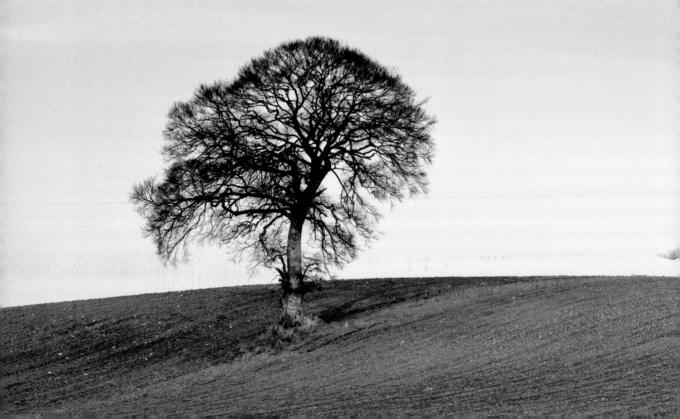

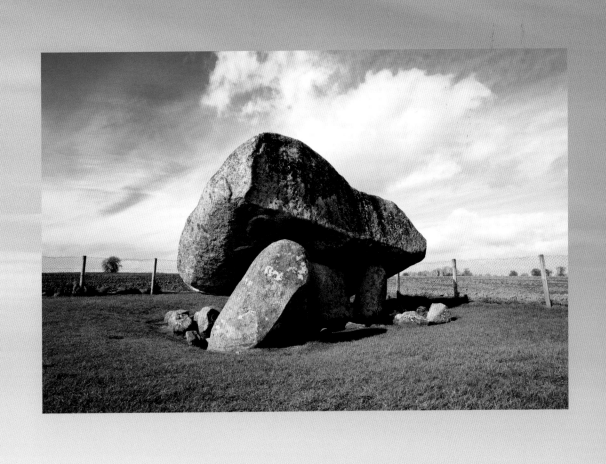

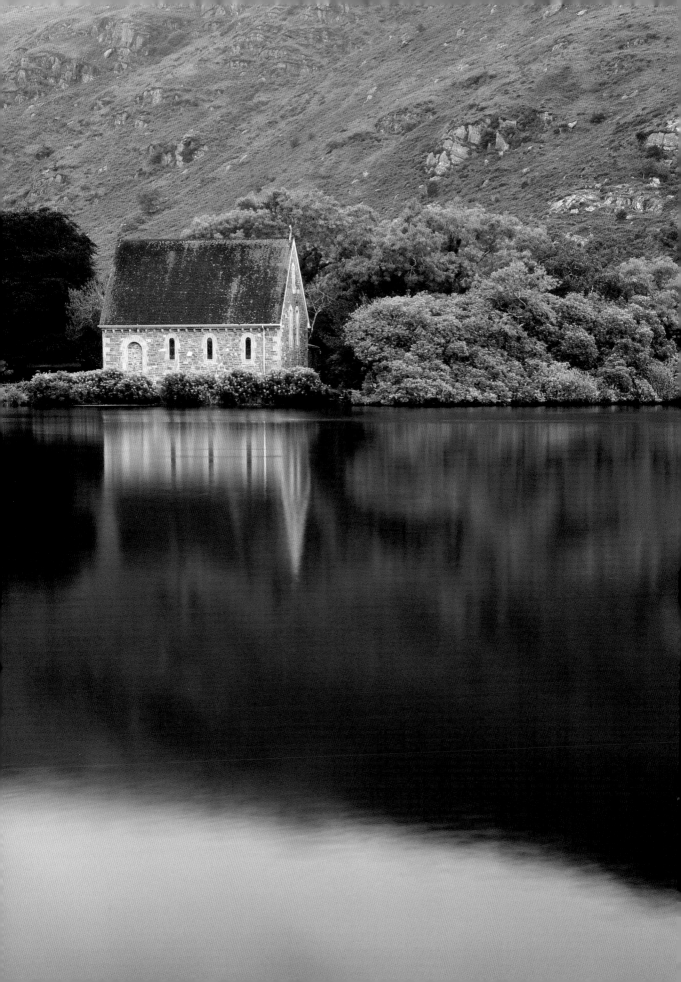

THE SOUTH WEST

In the South West, there's a healthy rivalry between Counties Cork and Kerry when it comes to beauty spots and assets: both are blessed with many and varied examples. The shoreline is washed by the Atlantic Sea, which has etched it with the constant thrust and drag of the waves. However, as this part of the world enjoys the warming influences of the Gulf Stream, it's not unusual to see palm trees and other tropical plants growing around. You'll find giraffes and monkeys at Fota Wildlife Park too!

Cork is proud of owning the gourmet capital of Ireland, the picturesque town of Kinsale, as well as being the home of Jameson Whiskey and Murphy's Stout.

The further west you go, the more rugged the countryside becomes, with the awesome tranquillity of the mist-enshrouded mountains of Kerry and the serenity of Killarney's lakes. It's easy to understand why people often describe these environs as heavenly.

On the horizon, the Skellig Rocks will catch your eye. Skellig Michael was once a monastic colony and is now a UNESCO World Heritage site and a bird sanctuary.

Left: Despite the motor trail, signposted walks and coffee shop, Gougane Barra, Co. Cork still holds a wild and magical atmosphere, as can be seen in this photograph of a dark summer's day.

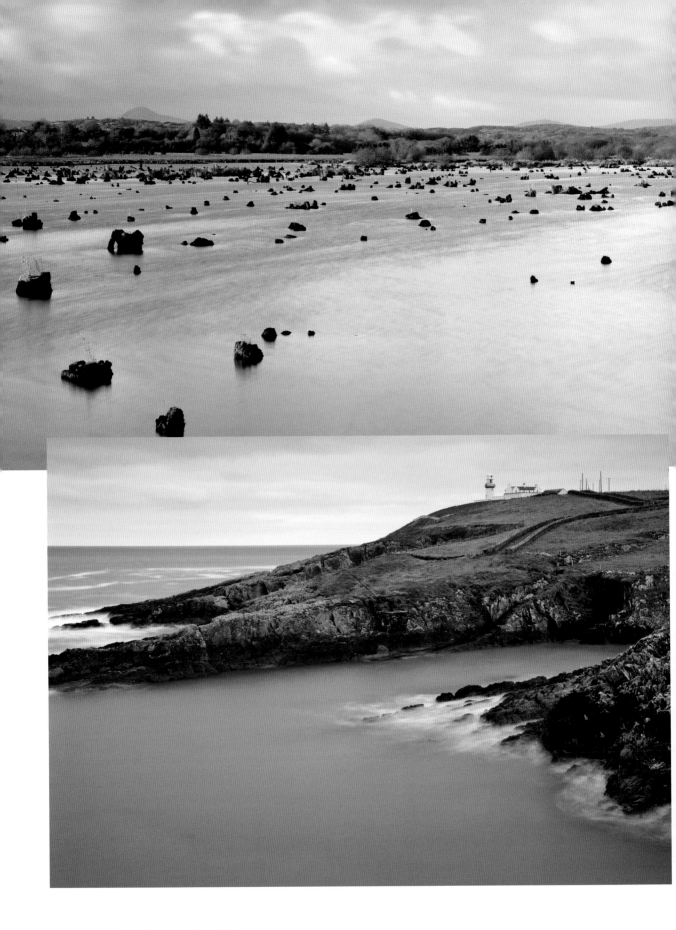

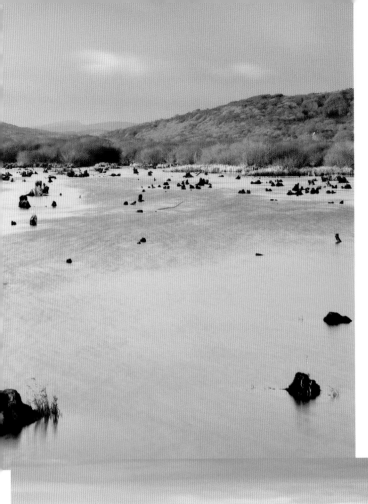

Left: The Gearagh, Co. Cork is an ancient alluvial soil forest, the only of its kind in western Europe. Made up of a network of channels formed by the river Lee, which separate islands covered in oak, ash, birch and other rarer species, it is an important feeding and resting place for wildfowl.
Opposite bottom: Galley Head Lighthouse, Co. Cork, built in 1875, is one of the two most powerful in Europe.
Below: Courtmacsherry Bay & Coolmain Point, Co. Cork.

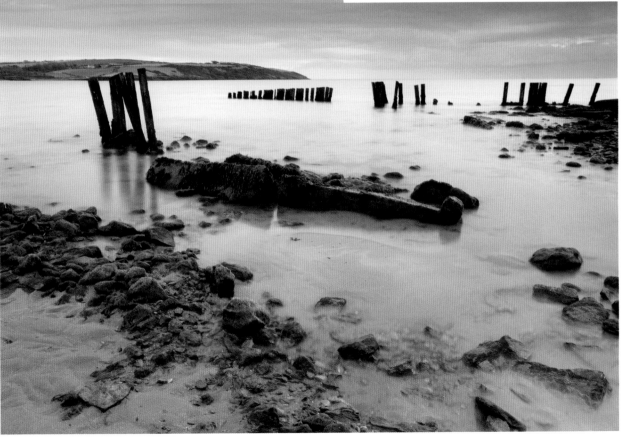

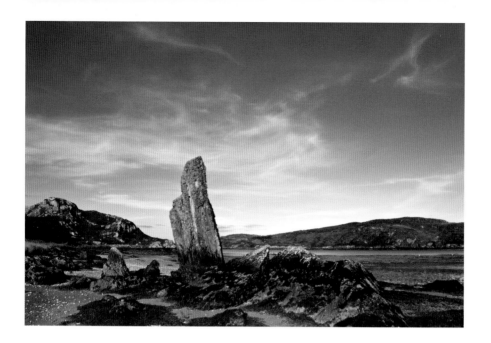

Above: Crookhaven, Mizen Peninsula, Co. Cork.
Below: Seaweed, beach & gulls, Inchydoney Island, Co. Cork.

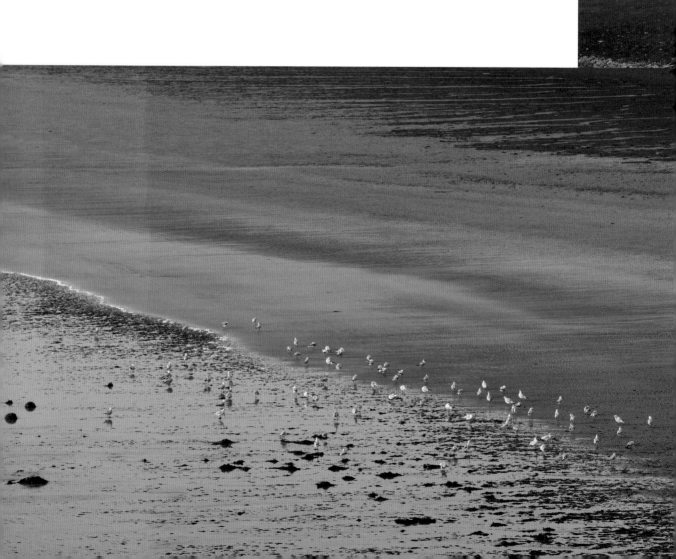

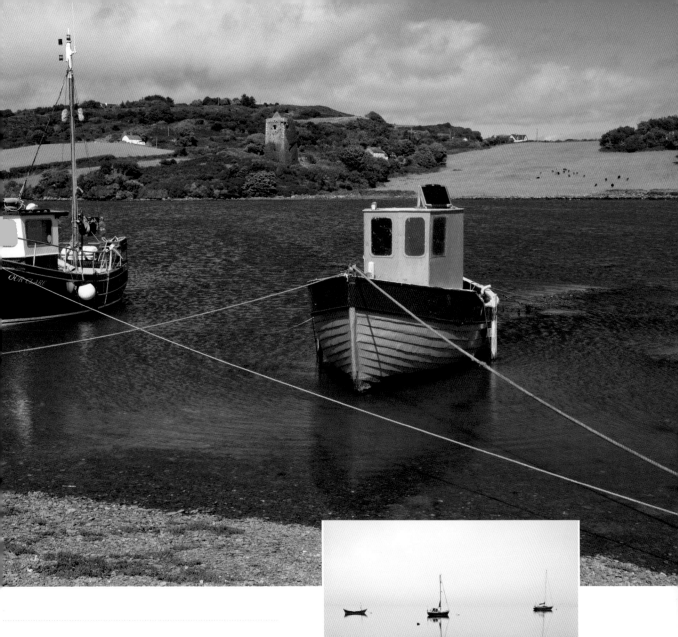

Above: Reen Pier, Co. Cork is one of the starting points for Whale Watching tours. To date, twenty-four species of whale and dolphin have been recorded in Irish waters including the Common Dolphin, Harbour Porpoise, Fin Whale and Minke Whale.
Right: Fog on Bantry Bay, Co. Cork.

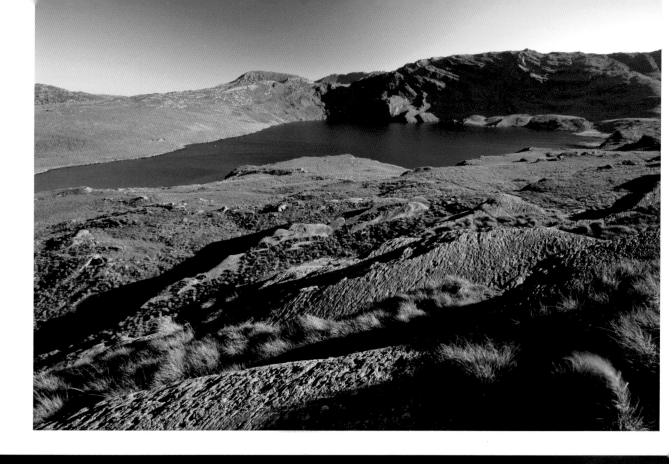

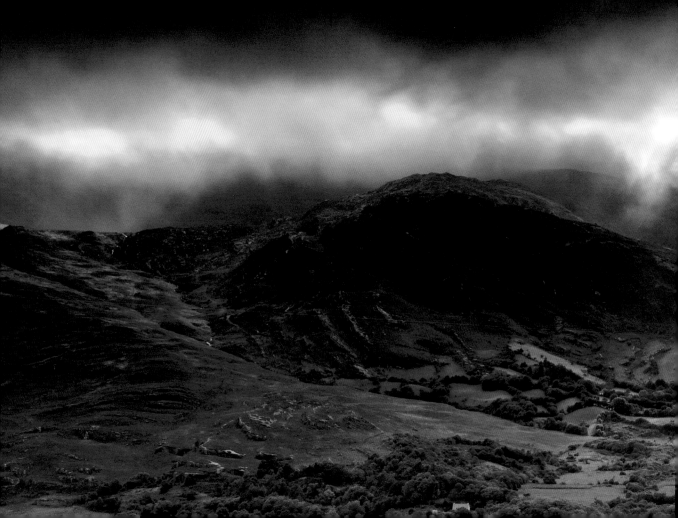

Opposite top left: Barley Lough, Co. Cork, one of the many lakes in the Caha Mountains, can be reached by an adventurous drive and a walk across squelchy bogland.
Below: The Caha Mountains, Co. Cork are the backbone of the Beara Peninsula. The mountain range of red sandstone stretches between Turner's Rock on the Glengariff to Kenmare road in the east and Healy Pass (**right**) in the West. Its modest height (the highest peak reaches just over 600m) is made up for by dramatic shapes and forms.

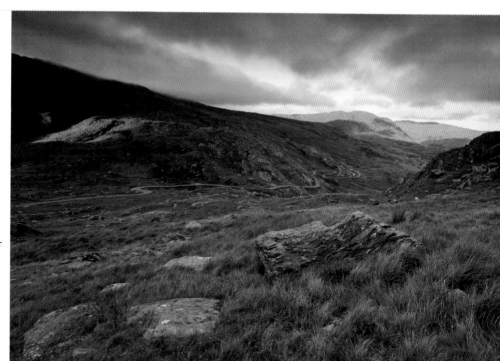

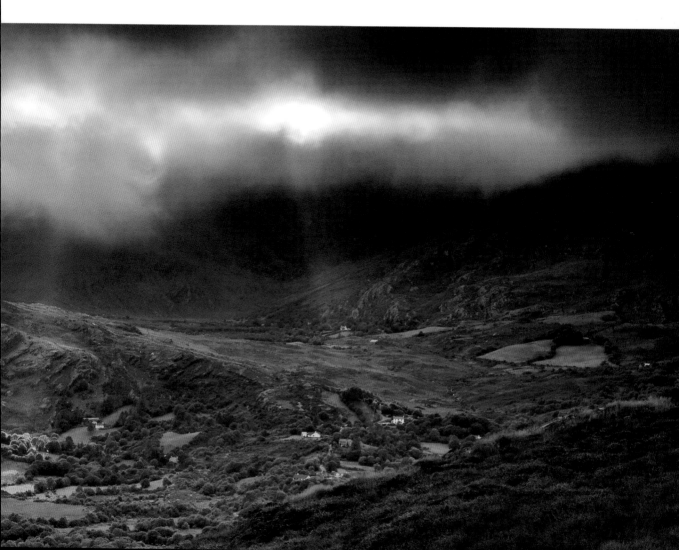

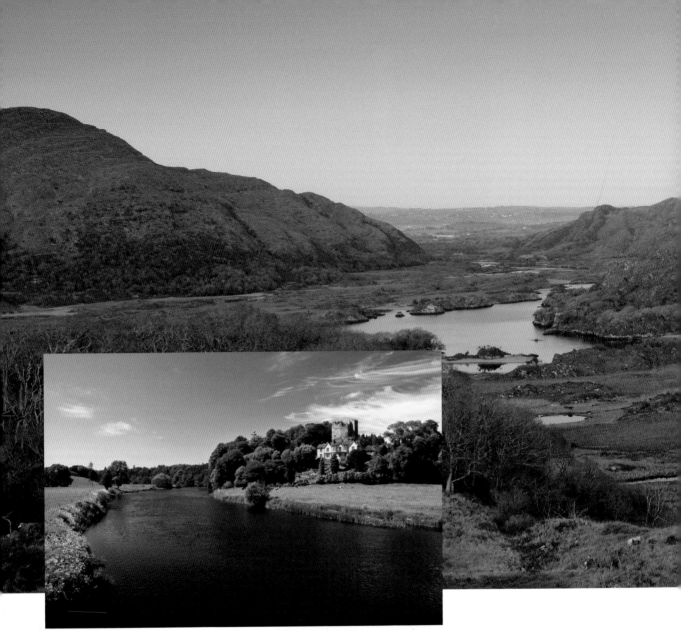
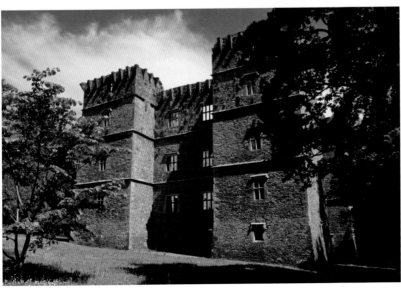

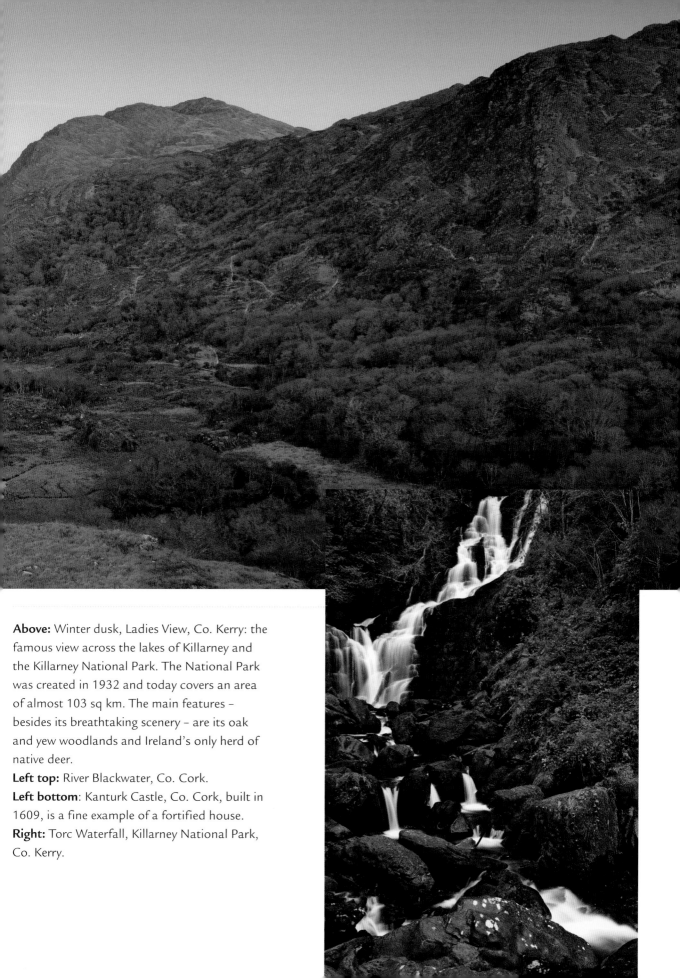

Above: Winter dusk, Ladies View, Co. Kerry: the famous view across the lakes of Killarney and the Killarney National Park. The National Park was created in 1932 and today covers an area of almost 103 sq km. The main features – besides its breathtaking scenery – are its oak and yew woodlands and Ireland's only herd of native deer.

Left top: River Blackwater, Co. Cork.

Left bottom: Kanturk Castle, Co. Cork, built in 1609, is a fine example of a fortified house.

Right: Torc Waterfall, Killarney National Park, Co. Kerry.

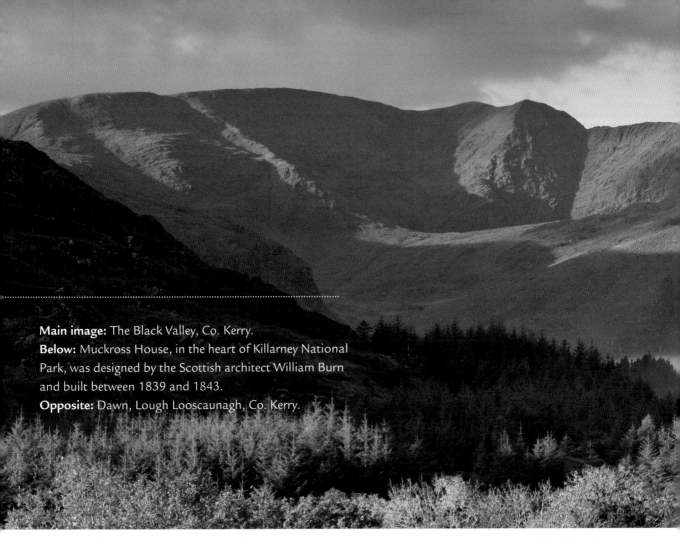

Main image: The Black Valley, Co. Kerry.
Below: Muckross House, in the heart of Killarney National Park, was designed by the Scottish architect William Burn and built between 1839 and 1843.
Opposite: Dawn, Lough Looscaunagh, Co. Kerry.

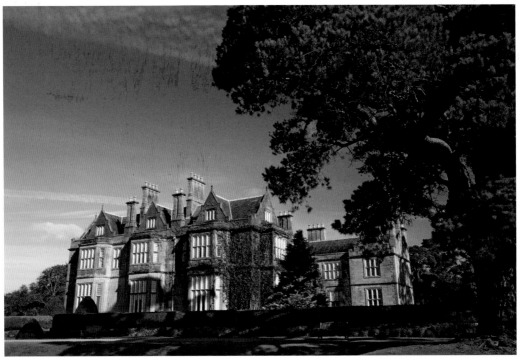

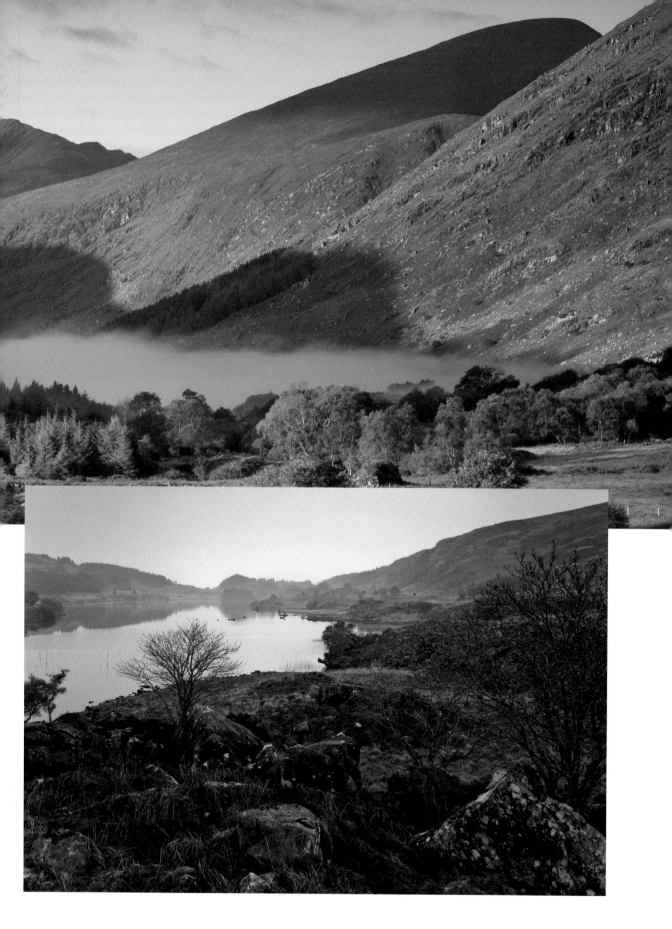

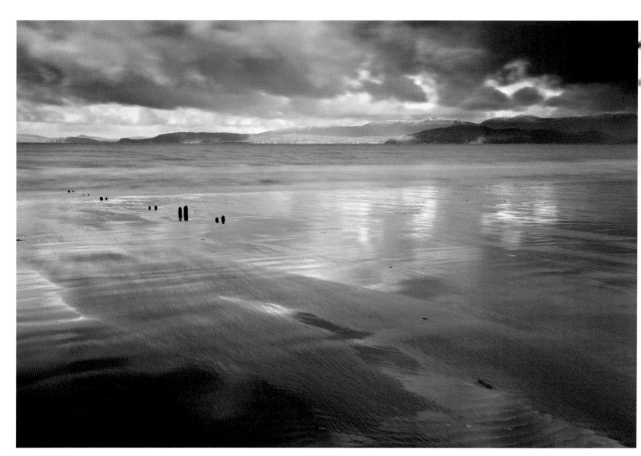

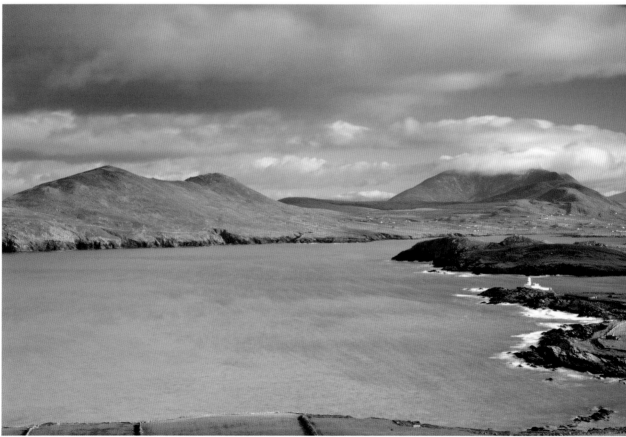

Opposite left: Rossbehy Strand, Iveragh Peninsula, Co. Kerry.

Below: View from Valentia Island, Co. Kerry.

Top right: Gallarus Oratory, Dingle Peninsula, Co. Kerry is an early Christian Church, which was built without mortar; despite being well over a thousand years old, the walls and roof are still waterproof. The only light sources are the door and a small window opposite the entrance. Legend has it that if a person leaves the church through this window, their soul will be cleansed.

Bottom right: Staigue Fort, Iveragh Peninsula, Co. Kerry is one of Ireland's best-preserved Iron Age stone forts. Its impressive walls are up to 5.5m high and 4m thick.

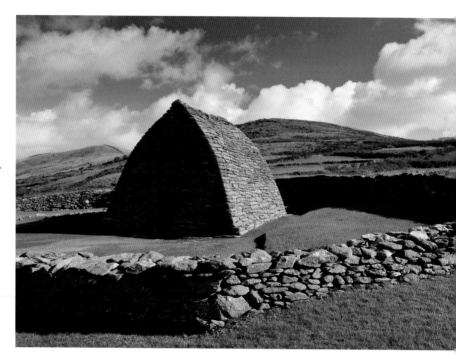

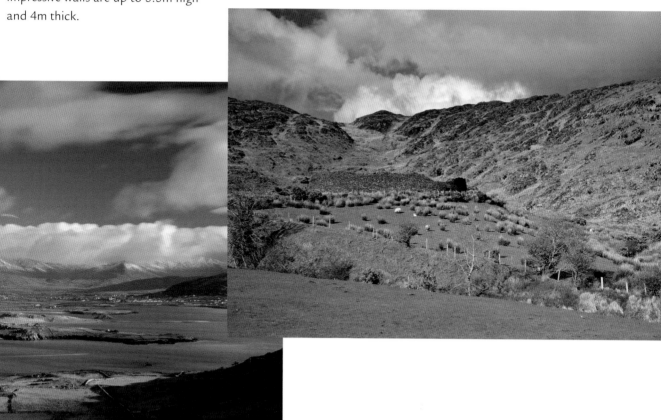

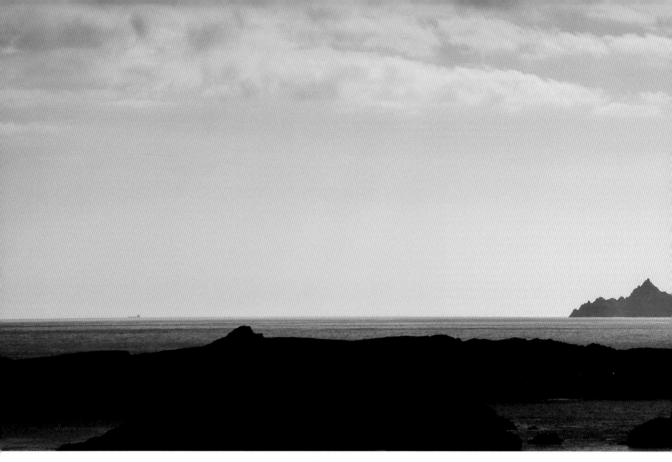

Above: The Skelligs from Valentia Island, Co. Kerry. The Skelligs are two rocky outposts in the Atlantic Ocean, 15 kilometres off the Kerry coast. Little Skellig is an important breeding site for gannets, kittiwakes, razorbills and puffins. Skellig Michael, or Great Skellig, is a UNESCO World Heritage site. It features a monastic settlement, founded in the 6th century, consisting of stone 'beehive huts' and oratories. During its history, the small community, probably twelve monks and an abbot, survived several Viking raids. Later, the unoccupied island became a pilgrimage site.
Left: Dingle Harbour, Dingle Peninsula, Co. Kerry.
Right: Sunset, Inch Strand, Dingle Peninsula, Co. Kerry.

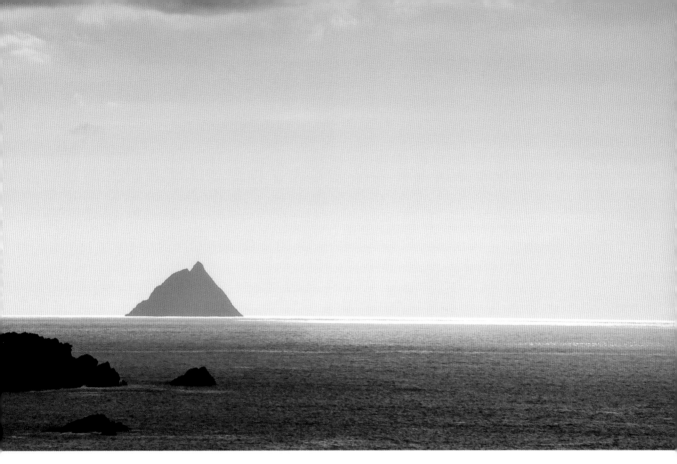

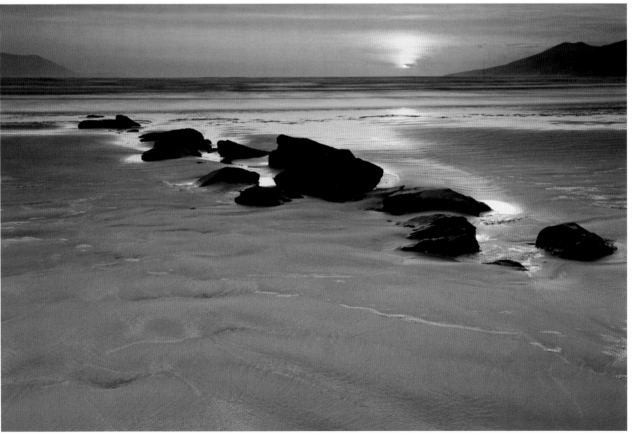

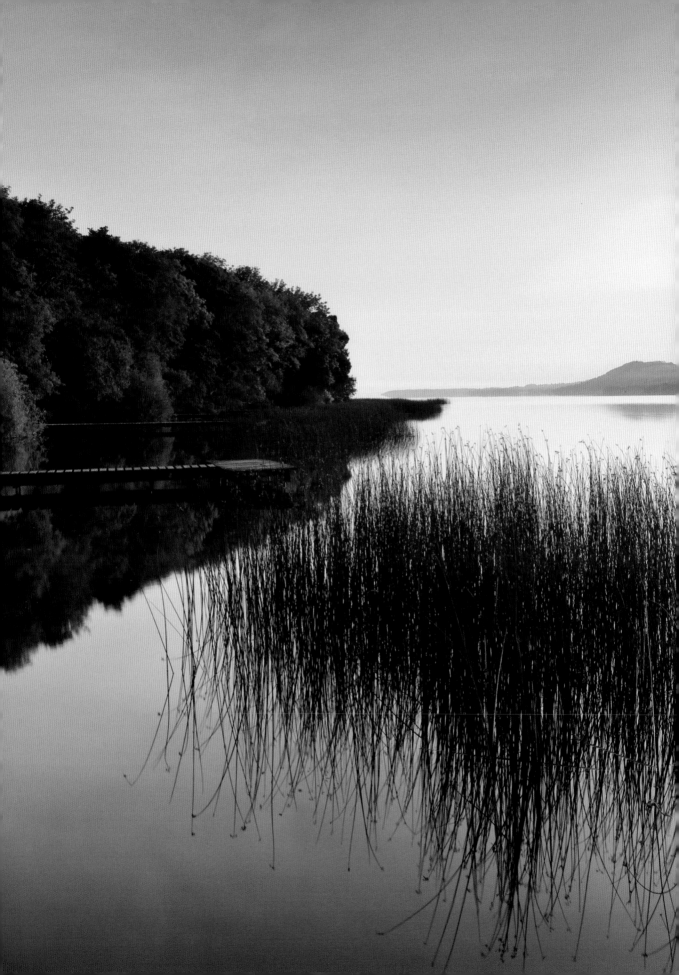

THE SHANNON REGION

The River Shannon is Ireland's longest river. At 370 km, it forms a natural boundary between the provinces of Leinster and Connaught and it provides some great scenery as it flows along.

Cruising on the river has become a very popular pastime, with lots of interesting stops along the way, not to mention mastering the art of negotiating the locks.

As you explore the Shannon Region, you'll see the Galtee Mountains and Lough Gur. If you make your way through Tipperary, you'll find it hard to miss its stunning landmark – the Rock of Cashel, the seat of the Kings of Munster from the fifth century until they donated it to the Church in 1101. It was in the custody of the Church until the Crowmellian invasions in 1700s.

In Co. Clare, surfers shun history to make their own by conquering some of the giant breakers. Further along you'll find the geological phenomenon known as the Burren, a limestone plateau where few trees manage to grow, yet the crevices in the 'pavements' are filled with an eclectic mix of plants of alpine and Mediterranean origins, leading it to be known as 'The Fertile Rock'. The name 'Burren' originates from the Irish word *'boireann'* meaning 'rocky / stony place'.

Left: Lough Derg, Killaloe, Co. Clare.

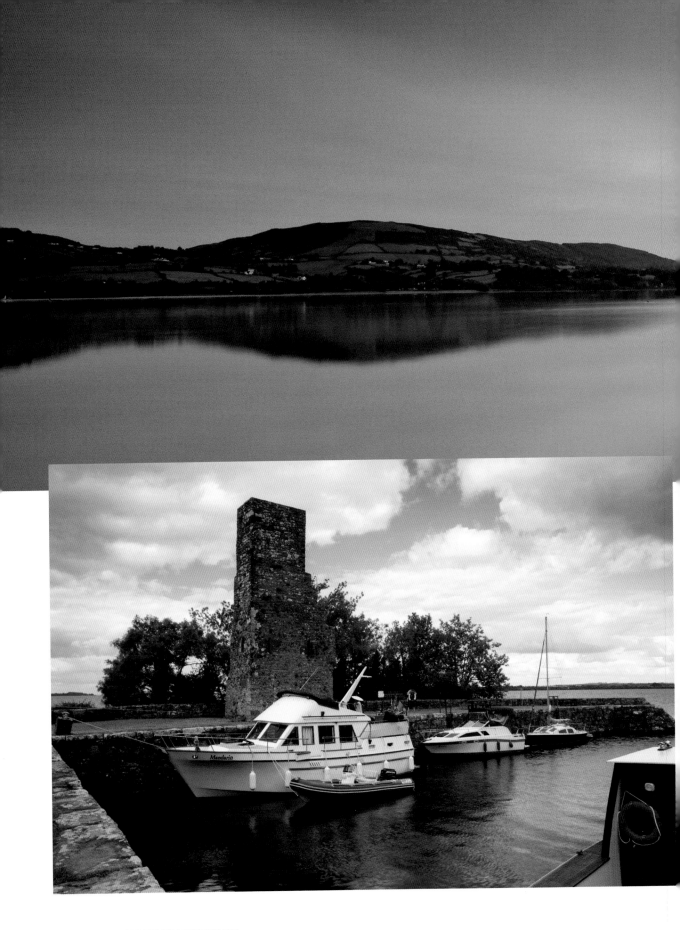

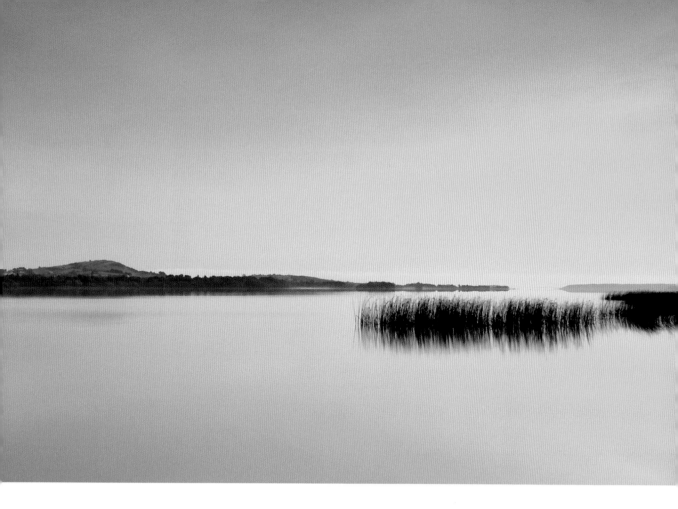

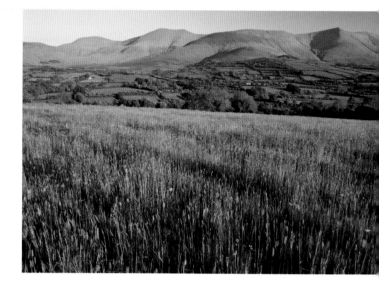

Top: Dawn on Lough Derg, Killaloe, Co. Clare, the third-largest lake in Ireland and the last of three major lakes on the River Shannon before it reaches the Atlantic Ocean. Lough Derg is a popular with cruisers and is also a well-known fishing spot.
Left: Garrykennedy Harbour, Lough Derg, Co. Tipperary.
Right: Glen of Aherlow and the Galtee Mountains, Co. Tipperary.

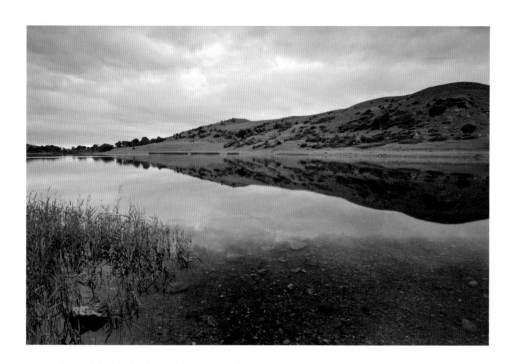

Above: The horseshoe-shaped Lough Gur, Co. Limerick is one of Ireland's most important archeological sites. The area around the lake has been inhabited for around five thousand years and numerous megalithic remains have been found.
Below: Old church, Lough Gur, Co. Limerick.

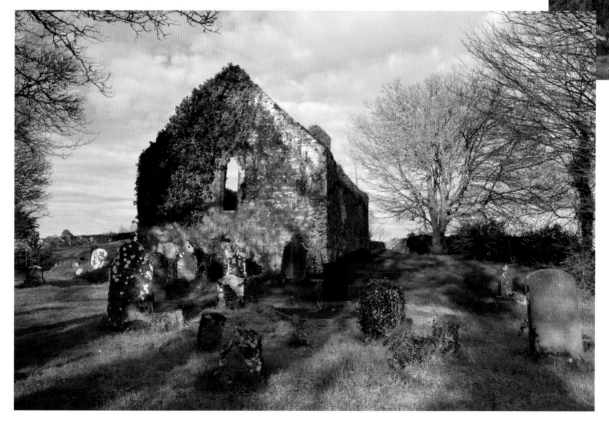

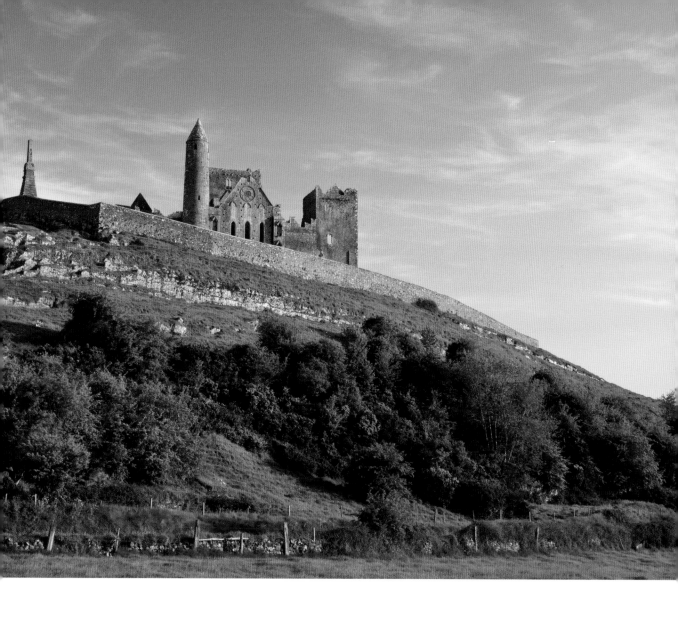

Above: Rock of Cashel, Co. Tipperary. On top of a limestone outcrop stands a spectacular group of Medieval buildings including a 12th-century round tower, high cross and Romanesque chapel, a 13th-century Gothic cathedral and a 15th-century castle. Before the Norman invasion, the Rock of Cashel was the traditional seat of the kings of Munster; legend has it that in the 5th century St Patrick converted the High King of Munster to Christianity on this site.
Right: Quin Abbey, Co. Clare.

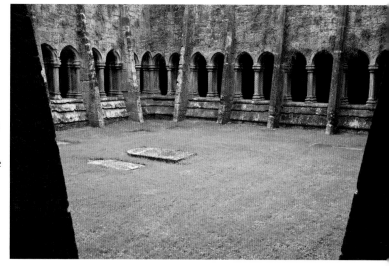

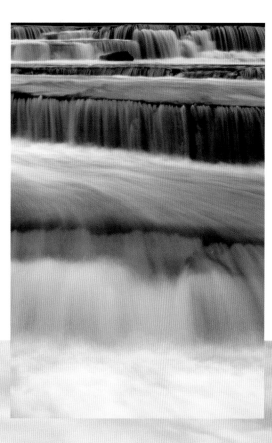

Left: Ennistymon Cascades, Co. Clare.
Below: Winter floods, Dromore Nature Reserve, Co. Clare: this nature reserve hosts a unique combination of habitats from rivers, lakes, turloughs (seasonal lakes) and callows (flooded meadows) to limestone pavement, fen peat and woodland.

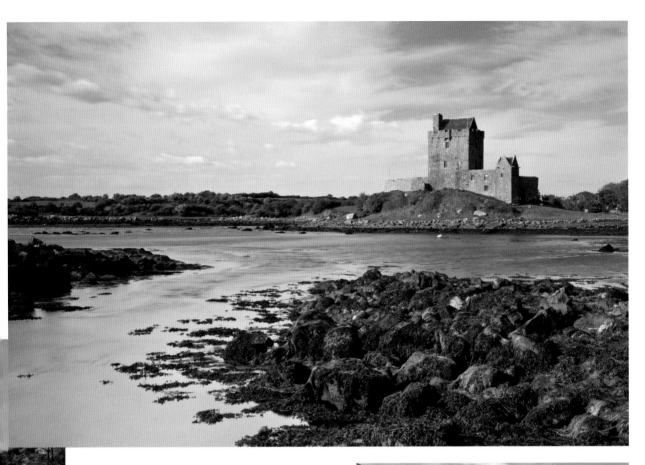

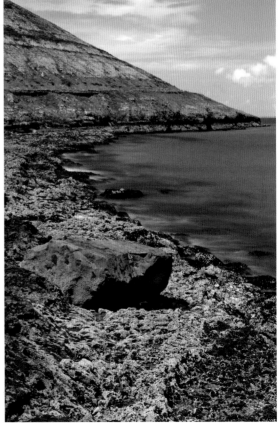

Above: Dunguaire Castle, Co. Galway, a 16th-century tower house just outside the village of Kinvara on the southeastern shore of Galway Bay.

Right: Black Head, The Burren, Co. Clare.

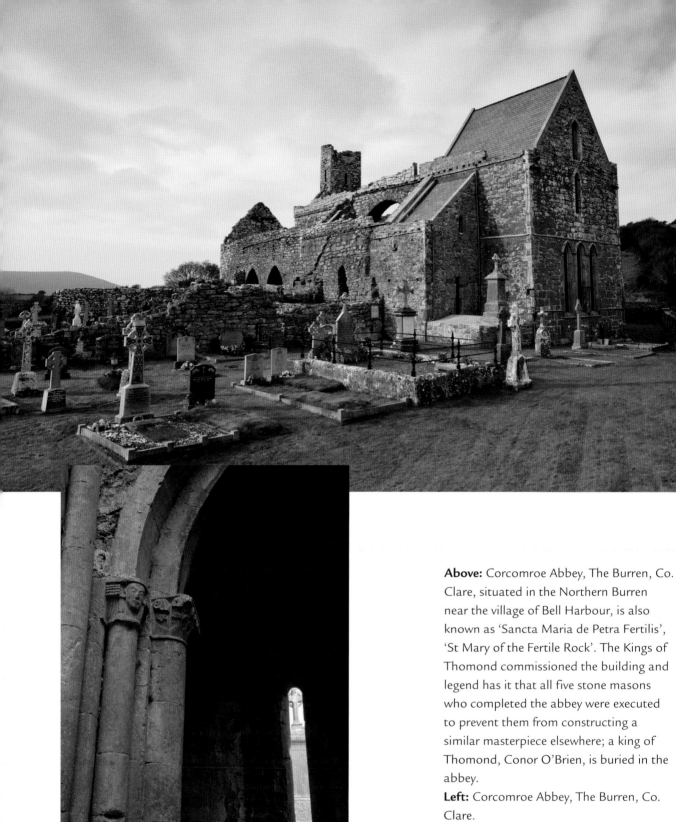

Above: Corcomroe Abbey, The Burren, Co. Clare, situated in the Northern Burren near the village of Bell Harbour, is also known as 'Sancta Maria de Petra Fertilis', 'St Mary of the Fertile Rock'. The Kings of Thomond commissioned the building and legend has it that all five stone masons who completed the abbey were executed to prevent them from constructing a similar masterpiece elsewhere; a king of Thomond, Conor O'Brien, is buried in the abbey.

Left: Corcomroe Abbey, The Burren, Co. Clare.

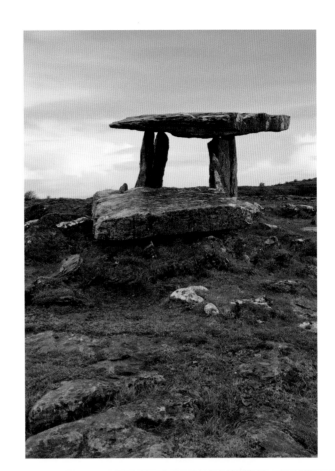

Right: Poulnabrone Dolmen, Co. Clare is the Burren's most famous portal tomb and dates back to around 4000 BC. During excavations, the remains of between sixteen and twenty-two adults and up to six juveniles were found.
Below: Hazel wood, Keelhilla Nature Reserve, The Burren, Co. Clare.

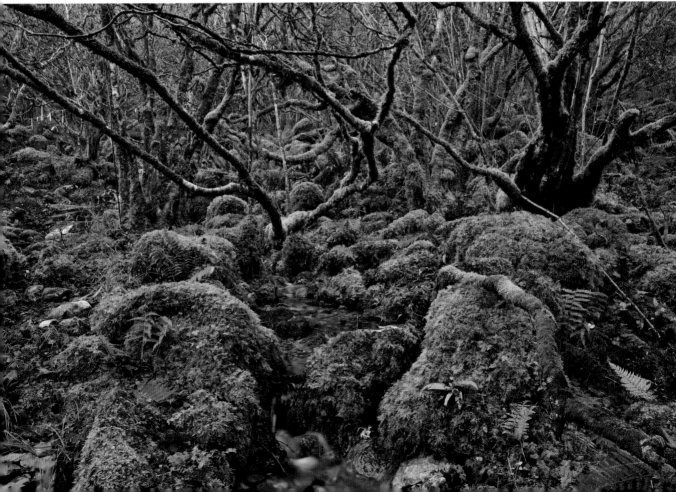

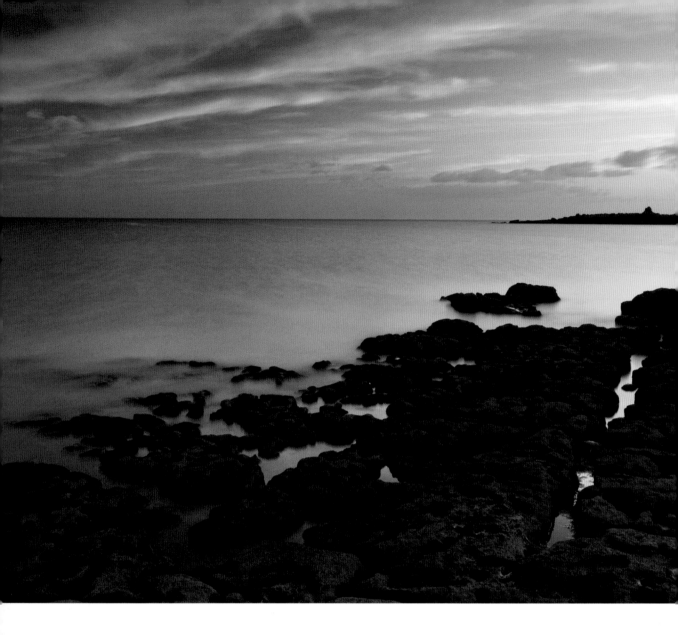

Above: Crab Island, Doolin, The Burren, Co. Clare.
Opposite top: Ballyryan, The Burren, Co. Clare. The Burren is one of the largest karst limestone landscapes in Europe. It got its strange appearance at the end of the last ice age when the retreating glaciers formed the limestone into pavements. The Burren is also famed for its plant-life; the area hosts a unique mix of alpine and Mediterranean species, including the Spring Gentian and several orchid species.
Opposite bottom: Surfers at Lahinch, Co. Clare.

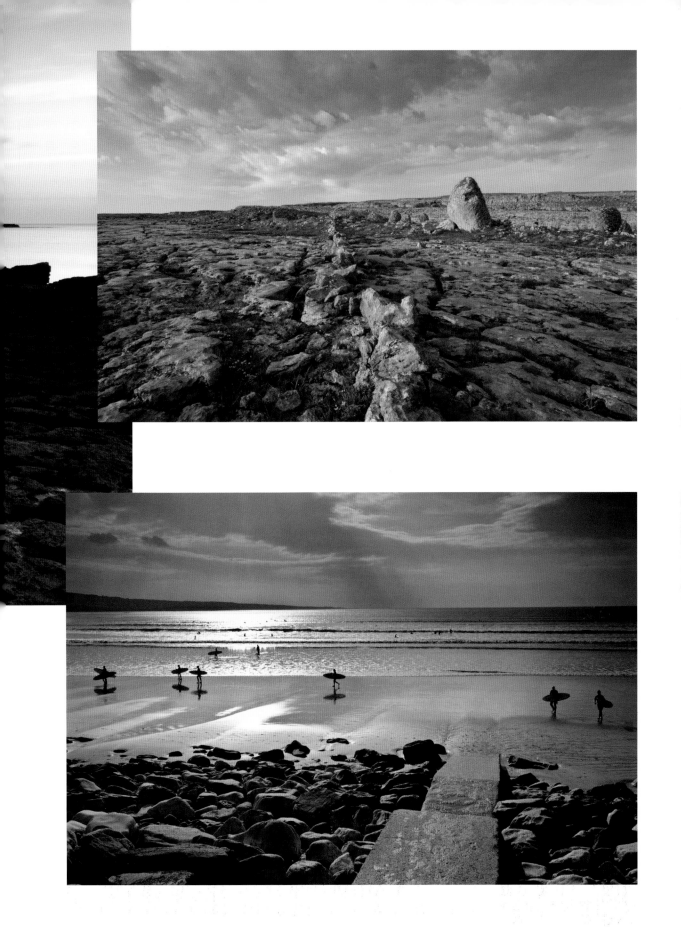

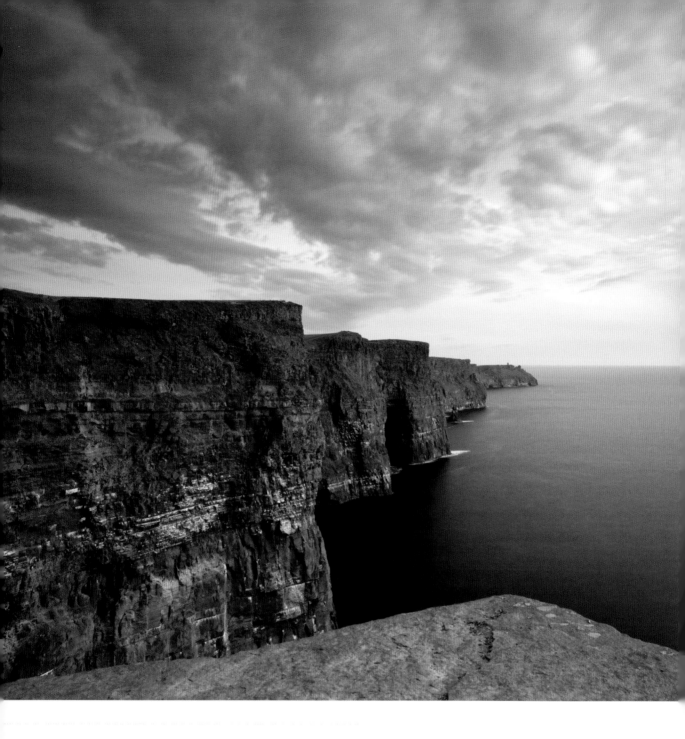

Above: The Cliffs of Moher, Co. Clare are one of Ireland's top attractions. They reach 214m at the highest point and stretch along the Atlantic Ocean for 8 kilometres. The cliffs are mainly made of Namurian shale and sandstone and the oldest rocks at the bottom of the cliffs date back approximately 300 million years.
Opposite top: Moore Bay, Kilkee, Co. Clare. Kilkee, one of Ireland's best-known seaside resorts, is the gateway to the Loop Head Peninsula, which has some of Ireland's most dramatic cliff sceneries. The horseshoe-shaped beach is protected by the Duggerna Reef, a natural wonder with three large rock pools and a multitude of smaller ones teeming with marine life.
Opposite bottom: Loop Head, Co. Clare.

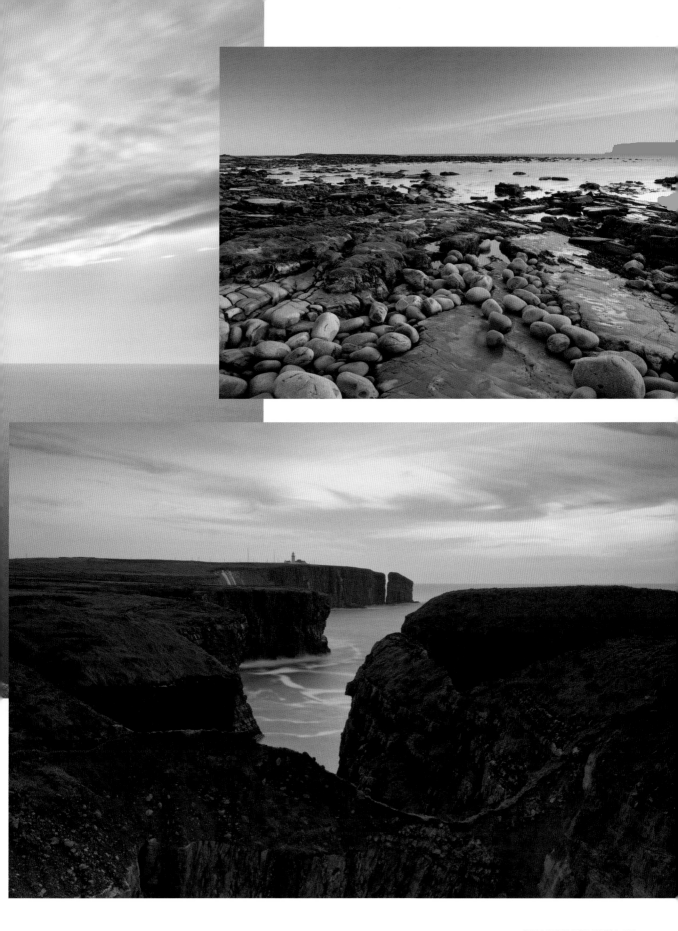

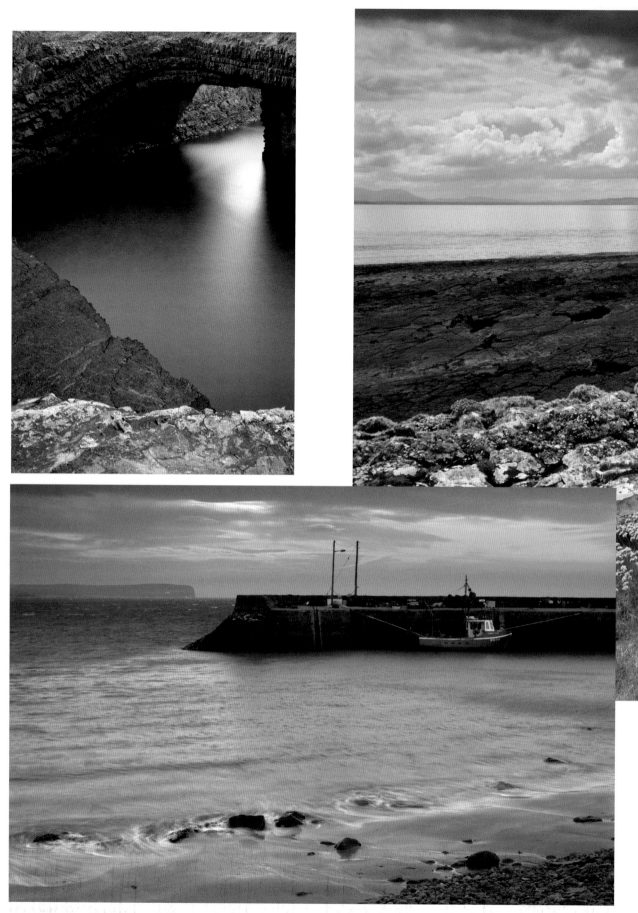

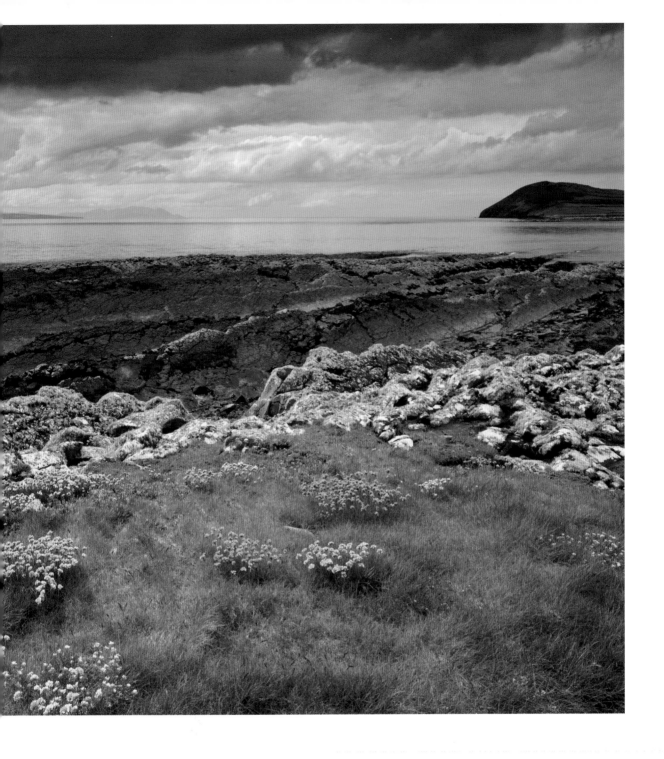

Opposite top left: Bridge of Ross, Loop Head Peninsula, Co. Clare; this natural rock arch is the only one remaining of three. The others have fallen victim to the forces of the Atlantic Ocean.
Opposite bottom: Kilbaha Bay, Loop Head Peninsula, Co. Clare.
Above: Rinevella Bay, Loop Head Peninsula, Co. Clare.

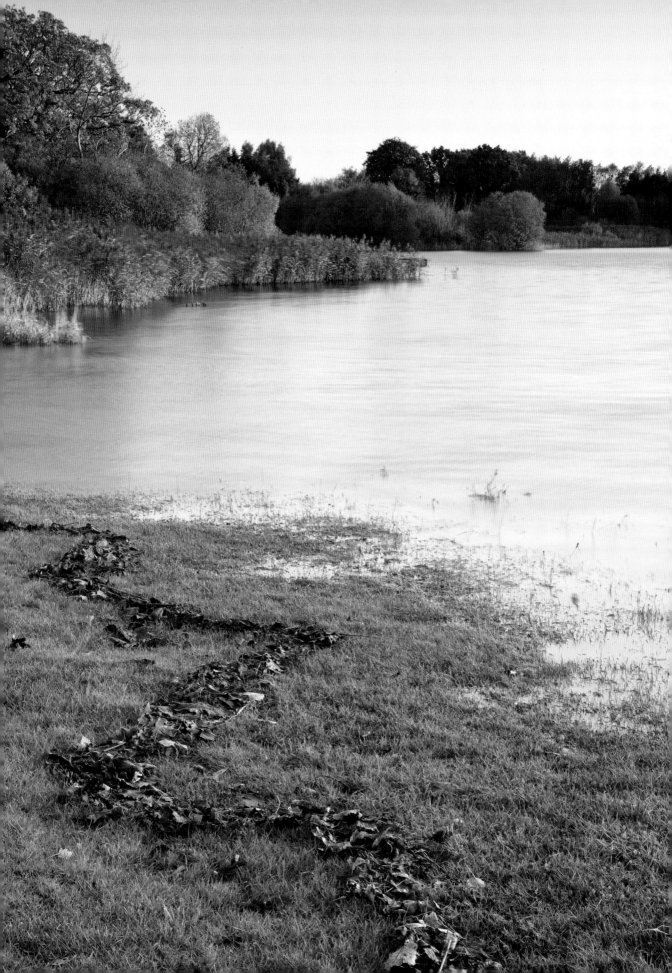

THE MIDLANDS

Ireland's Midlands offer a cocktail of plains and rich agricultural lands, with the Slieve Bloom Mountains providing plenty of opportunities for walks and rambles as well as the nineteen-mile Slieve Bloom Way.

Birr, Co. Offaly should not be missed; it's designated as an Irish Heritage Town and is a mix of history, architectural styles and so much more. However, it is for its famous telescope that Birr gained international acclaim. Located in the marvellous Birr Castle grounds, the 32-inch outdoor construction was the largest telescope in the world for over seventy-five years. The Parsons family who live here have been innovators in many fields and they have created an amazing garden with one section designed in hedging to form a monastic cloister.

Also in Offaly you'll find the medieval remains of Clonmacnois monastery, founded by Saint Ciaran. It's where many kings of Tara and Connaught are buried and is still a place of pilgrimage on his feast day, 9 September, each year.

Left: Hodson Bay, Lough Ree, Co. Roscommon. Lough Ree is the second largest lake on the Shannon and claims its own lake monster; the legend of the Lough Ree Monster is centuries old, but the first recorded sighting was on 16 May 1960. Three priests, who were enjoying a quiet day of fishing, noticed a strange creature with a serpent-like head not far from their boat. Despite several more sightings and investigations, no physical evidence of the monster's existence has been found.

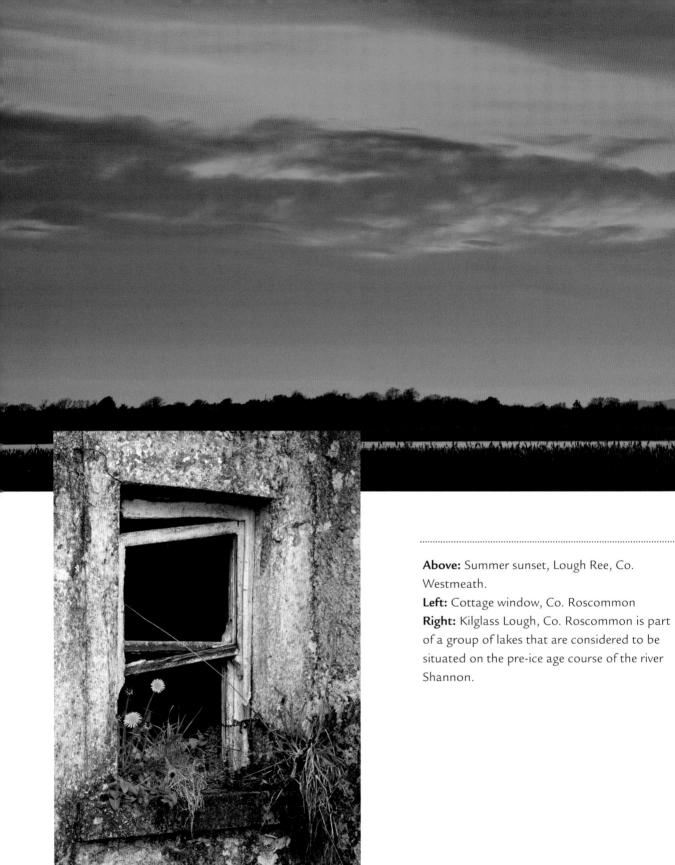

Above: Summer sunset, Lough Ree, Co. Westmeath.
Left: Cottage window, Co. Roscommon
Right: Kilglass Lough, Co. Roscommon is part of a group of lakes that are considered to be situated on the pre-ice age course of the river Shannon.

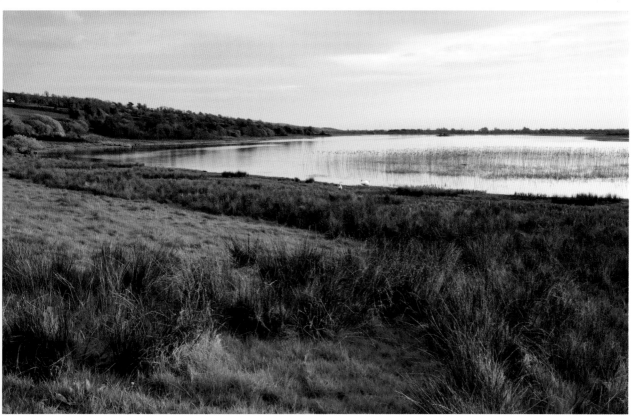

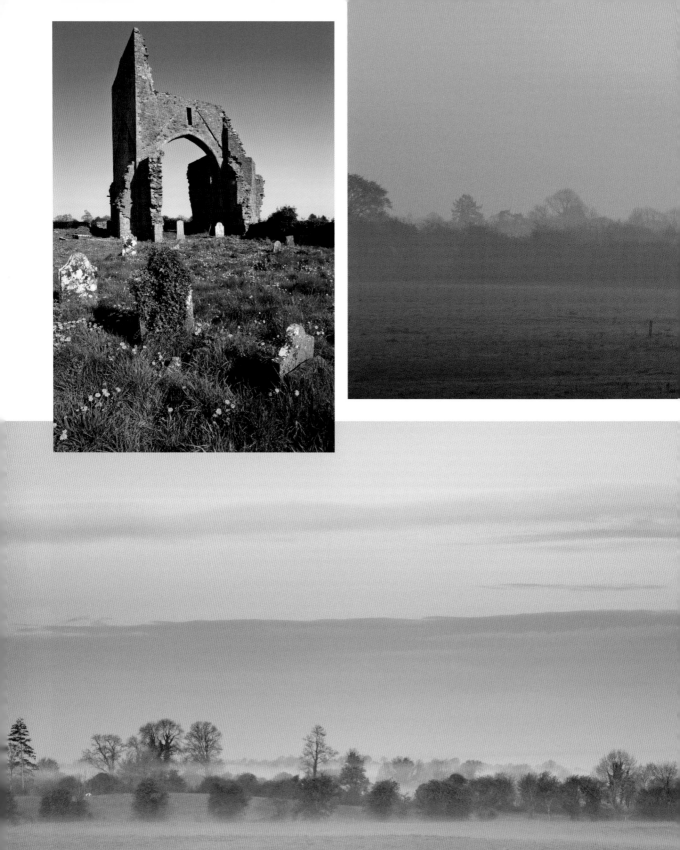

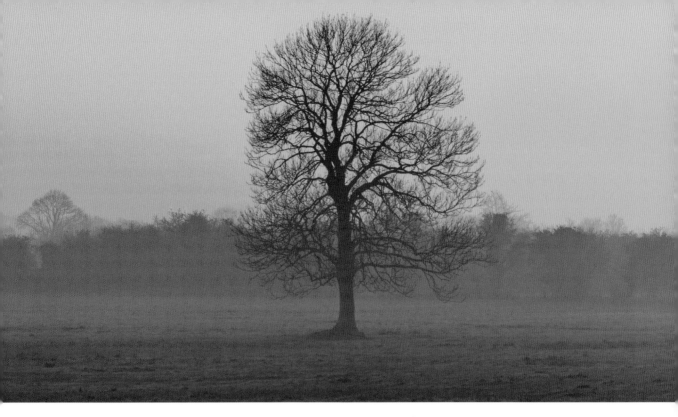

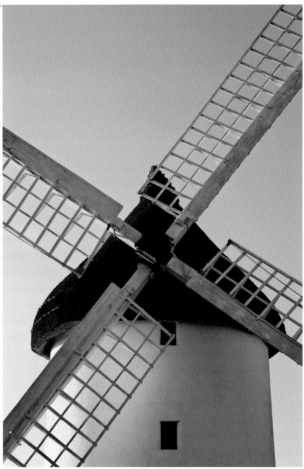

Opposite top: Abbeylara Monastery, Co. Westmeath.

Above: Dawn, Co. Offaly.

Left: A picture postcard view of the Midlands: Fields, hedgerows, trees and a glorious spring dawn near Athlone, Co. Westmeath.

Right: Elphin Windmill, Co. Roscommon was built around 1730 by the Bishop of Elphin, Edward Synge, to provide meal for the local population. Only a hundred years later it had fallen into disuse and ruins. In 1996 it was restored and opened to the public.

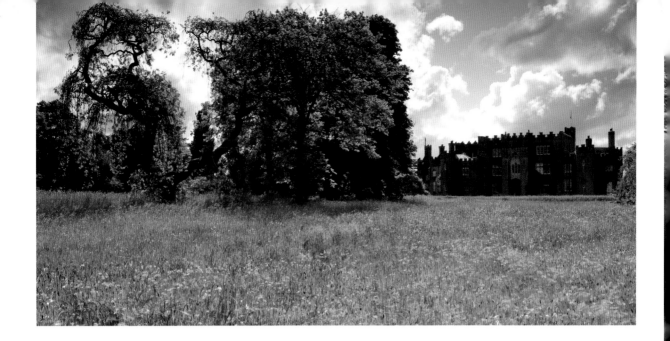

Above: The current Birr Castle, Co. Offaly was built in the early 17th century, but the site has hosted a castle in some form since the early 12th century. The castle and extensive grounds are owned by William Brendan Parsons, the seventh Earl of Rosse. The main feature of the grounds is the Great Telescope, built by the third Earl of Rosse, in 1845. For more than half a century, it was the biggest and most famous telescope in the world (it is mentioned in Jules Verne's From the Earth to the Moon) and was in use until 1914.

Below: The Great Telescope, Birr Castle & Gardens, Co. Offaly.

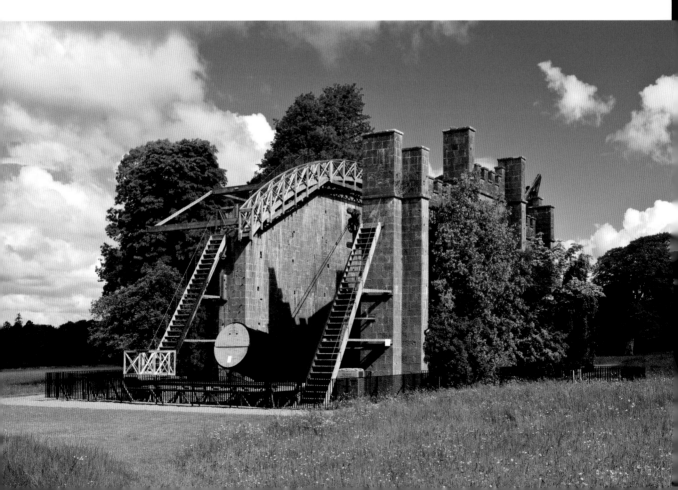

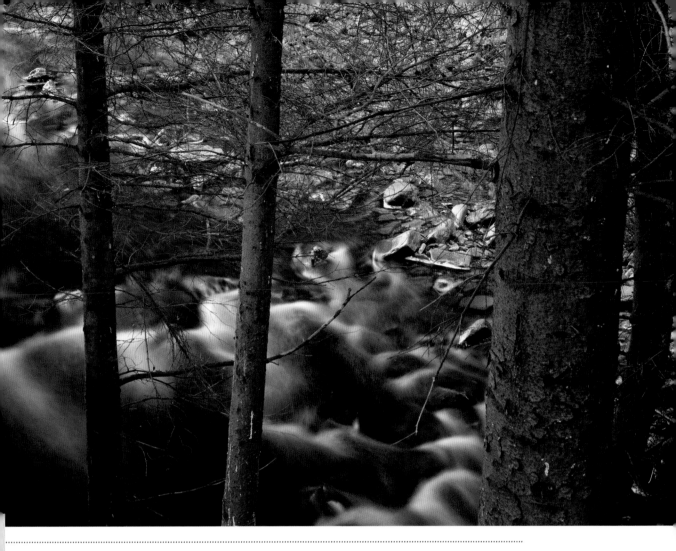

Above: Glenbarrow, Slieve Bloom Mountains, Co. Laois; these are among the oldest mountains in Europe and rise to a height of 526 metres overlooking Ireland's central plain. The area is made of blanket bog, forest and hidden valleys.
Below: Hay, near Kinnitty, Co. Offaly.

Right: River Shannon at Clonmacnois, Co. Offaly; Ireland's longest river has been an important waterway since antiquity.

Below: The Rock of Dunamase, Co. Laois rises out of a flat plain, dominating the surrounding landscape. The castle that stands on the Rock today was built in the 12th century, but excavations show that the Rock was first settled in the 9th century.

Opposite right: Clonmacnois Castle.

Opposite bottom: Clonmacnois, Co. Offaly is one of Ireland's most important and best-known monasteries. It was founded in 545 by St Ciaran. Its strategic location made it a major centre of religion, learning, craftsmanship and trade by the ninth century, but also made it target for frequent attacks by Vikings and Anglo-Norman forces. After the 12th century it fell into decline and was finally destroyed by English forces in 1552.

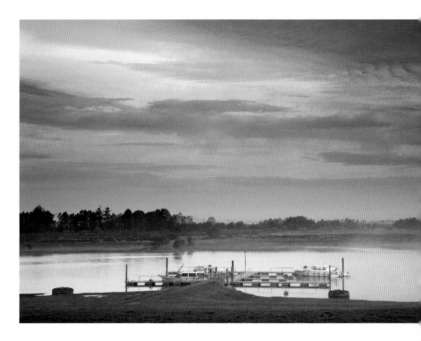

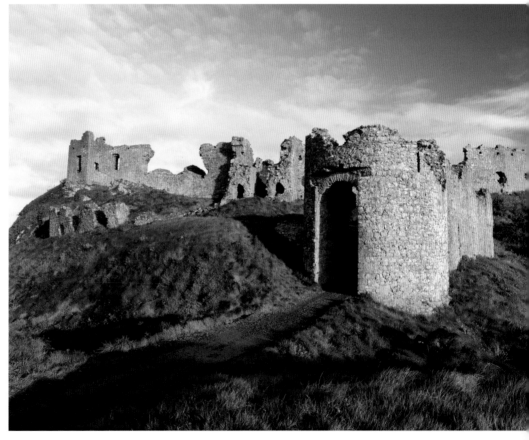

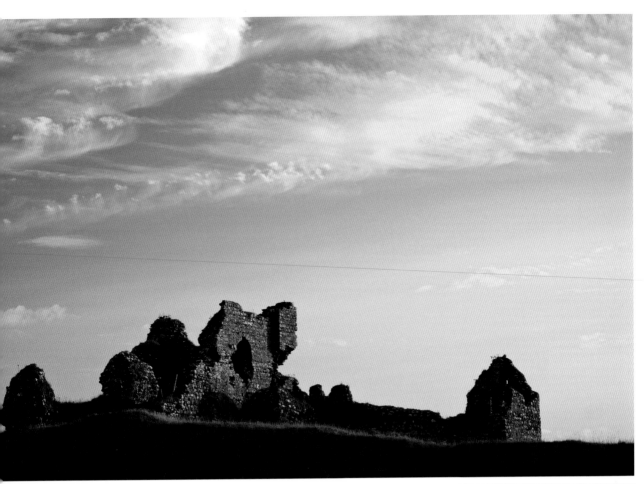

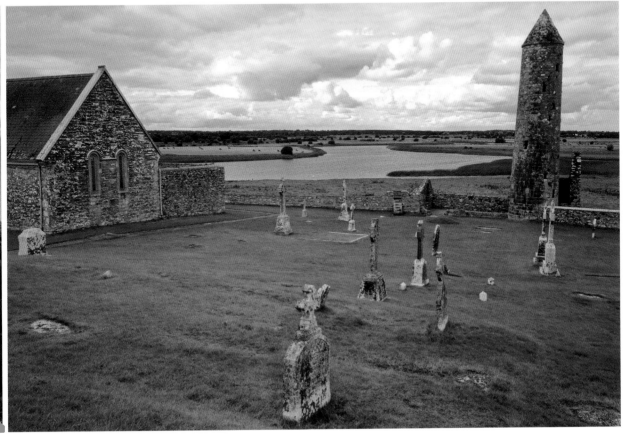

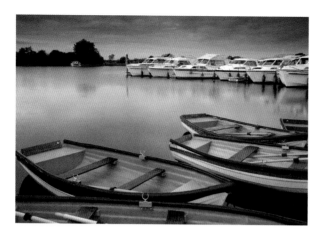

Left: Banagher Harbour, Co. Offaly.
Opposite top: Clonfert Cathedral, Co. Galway. The original monastery at Clonfert was founded in 563 by St Brendan the Navigator and became Ireland's foremost monastic school. Today, only the cathedral, with its Hiberno-Romanesque doorway dating back to the 12th century, remains.
Below Left: Clonfert Cathedral Entrance, Co. Galway.
Opposite bottom: Lough Oughter Castle, Co. Cavan.

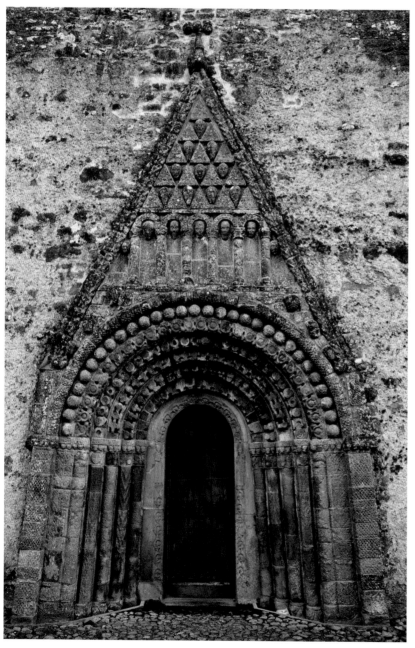

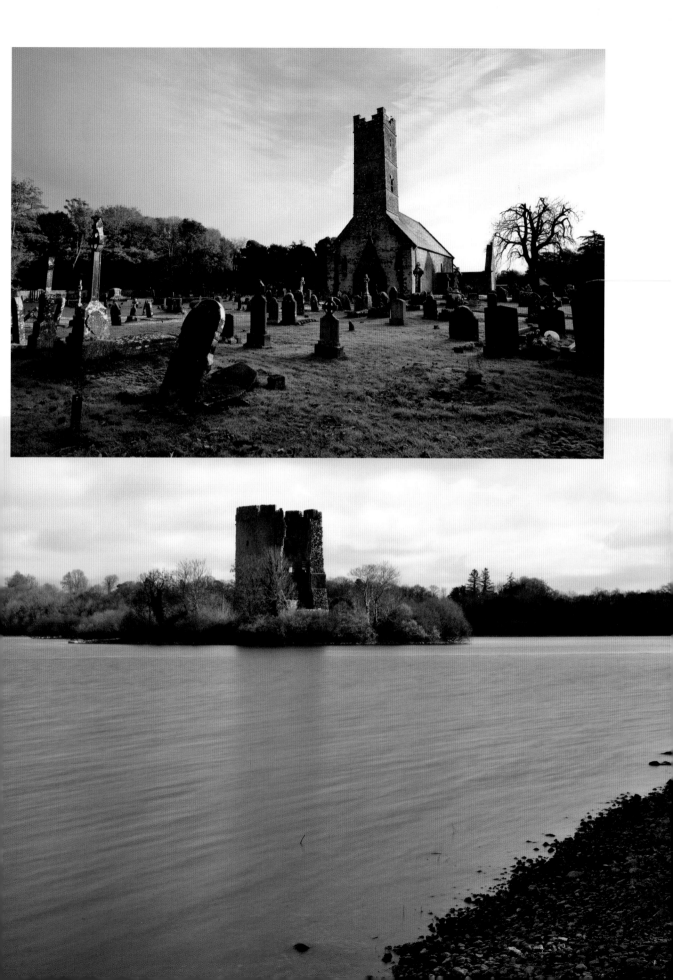

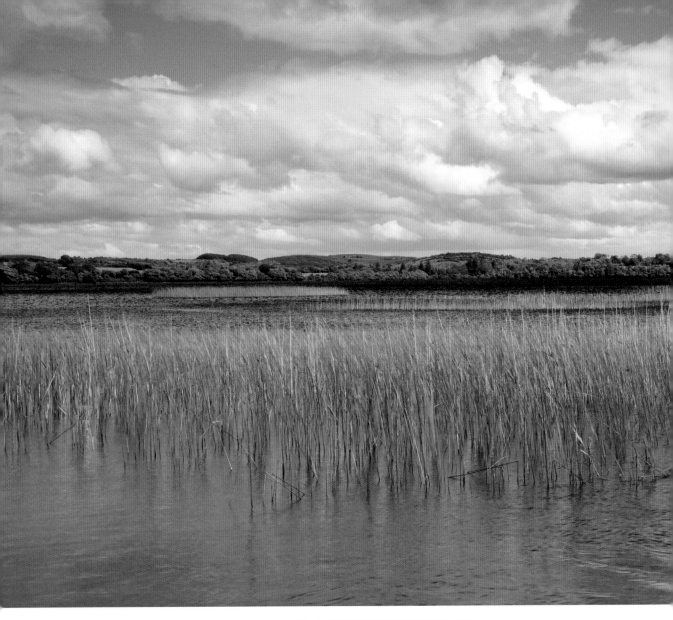

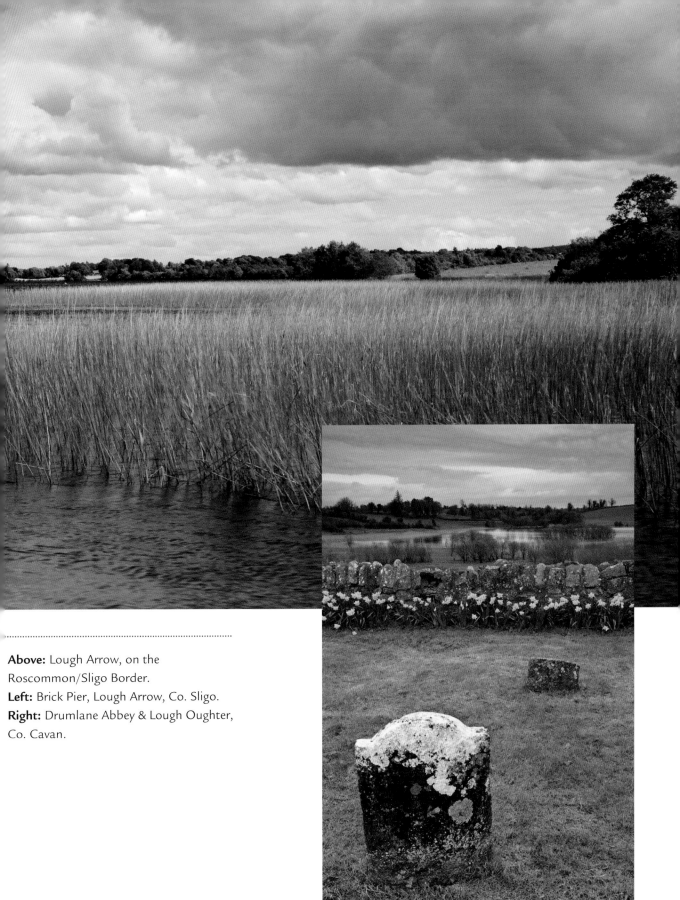

Above: Lough Arrow, on the
Roscommon/Sligo Border.
Left: Brick Pier, Lough Arrow, Co. Sligo.
Right: Drumlane Abbey & Lough Oughter,
Co. Cavan.

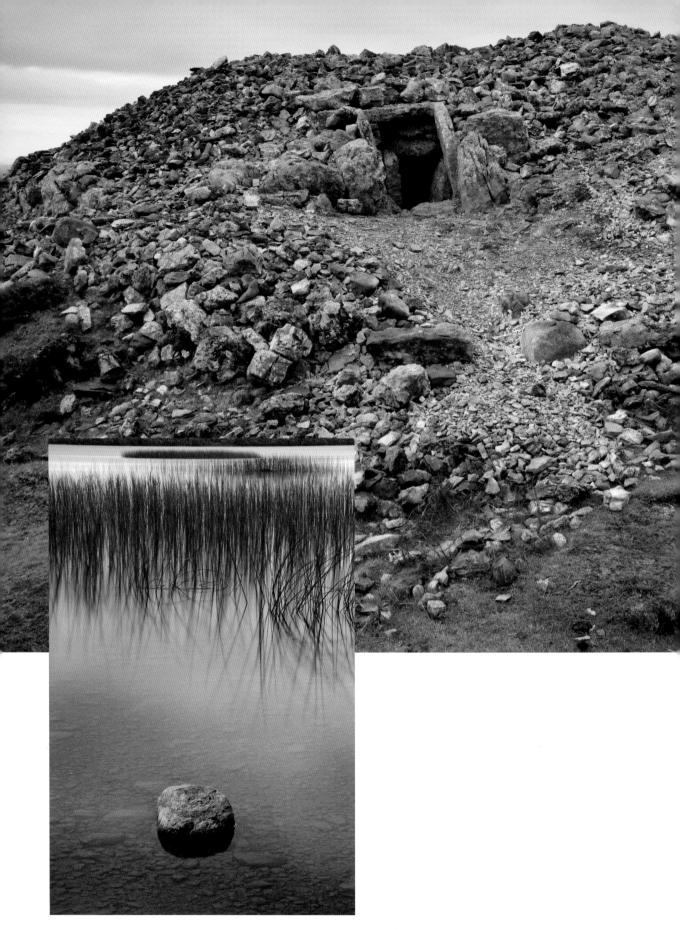

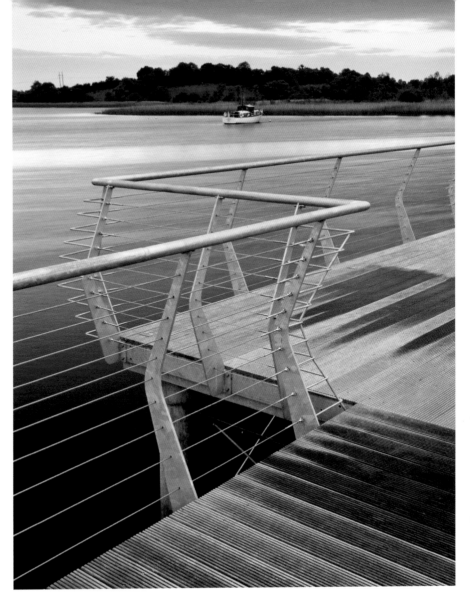

Opposite top: Carrowkeel Cairn, Co. Sligo is one of Ireland's least known Neolithic sites, but also one of the most impressive. Some twenty-one cairns, of which fourteen are excavated, are scattered over the Bricklieve Mountains in prominent positions and are visible for many miles around.
Opposite left: Stone & reeds, Lough Arrow, on the Roscommon/Sligo border.
Right: Carrick-on-Shannon, Co. Leitrim is the first and most northerly major harbour on the Shannon.

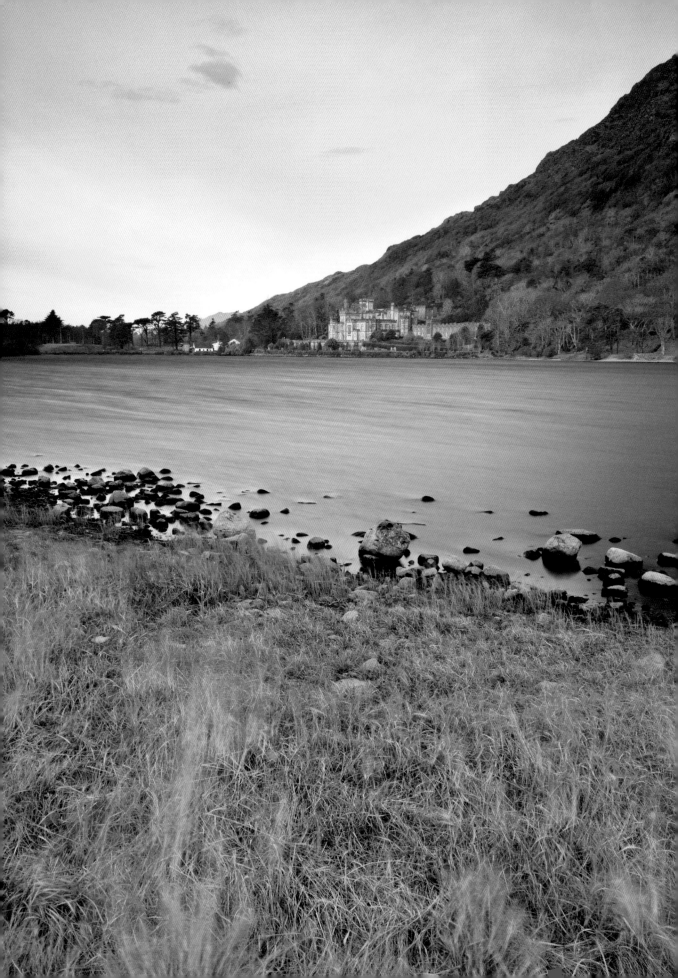

THE WEST

The West is characterised by the dry stonewalling dividing the windswept fields, the wonderful Twelve Bens Mountains, fishing on Lough Corrib, as well as by native Irish speakers. Then there's the challenge of Croagh Patrick, where Saint Patrick is said to have spent forty days fasting and praying. Every year pilgrims climb this, often barefoot, on the last Sunday in July – Reek Sunday.

Galway is the capital of the West and is frequently still referred to as 'the City of the Tribes', because twelve powerful merchant families controlled it until Cromwellian times.

The further west you go, you begin to see the magical silvery light beloved of photographers and painters alike and you will enjoy some of the most glorious sunsets imaginable. You can visit several of the islands off the west coast – Inishbofin, Clare Island, the Aran Islands – each with a distinct character of its own.

Connemara has a special kind of beauty and appeal, with its blanket bogs and moorlands, little villages and wonderful scenery. It was here in Clifden that the first transatlantic flight landed in 1919 piloted by Alcock and Brown.

Left: Kylemore Abbey, Co. Galway is the only Irish Benedictine convent and was originally founded for Benedictine nuns who fled Belgium in World War I. The building itself, originally known as Kylemore Castle, was erected between 1863 and 1868.

Right: Lough Rea, Co. Galway.

Below: This fishing house, built on a platform on the river Cong at Cong Abbey, Co. Mayo, has a trapdoor in the floor through which fishing lines or nets could be lowered to catch fish. Cong Abbey, founded in the 7th century, has been destroyed and rebuild several times over the centuries.

Opposite bottom: Kilmacduagh Church & Roundtower, Co. Galway; the round tower at Kilmacduagh monastery is Ireland's version of the tower of Pisa. It leans over half a metre from the vertical.

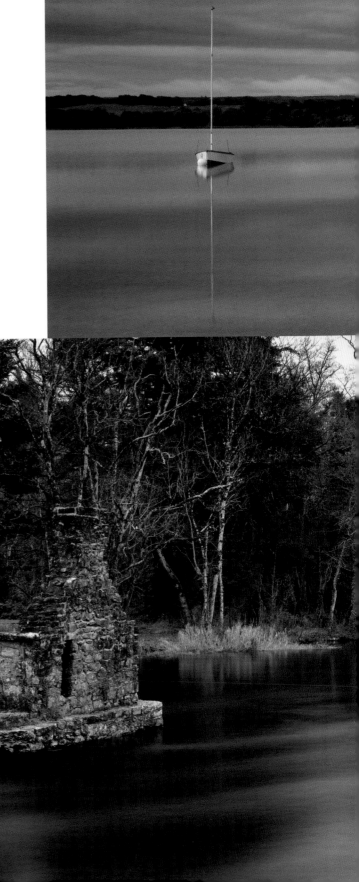

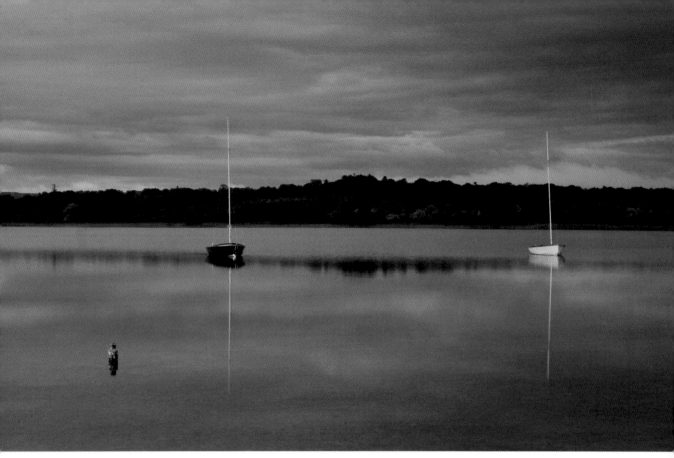

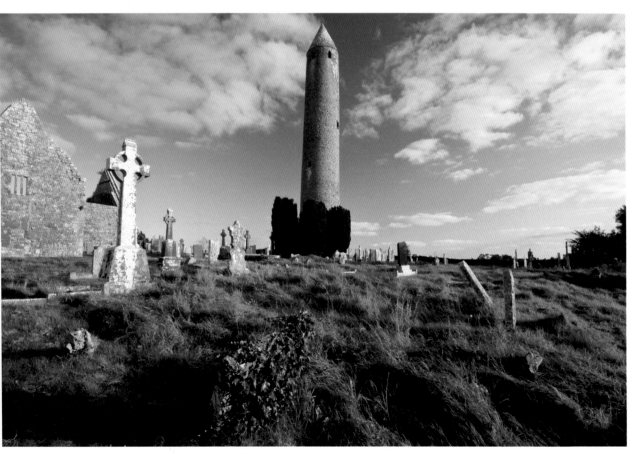

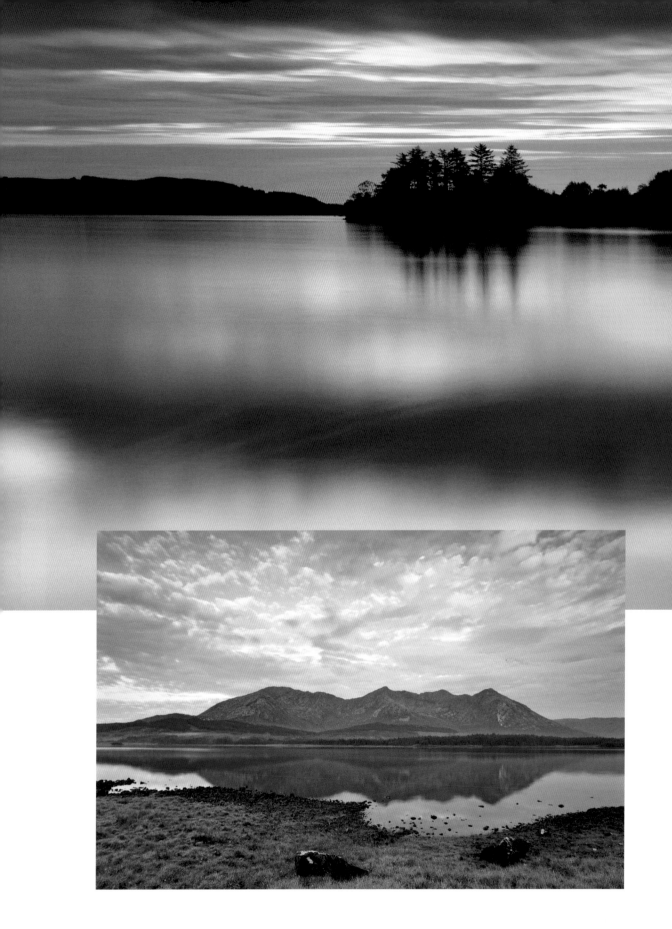

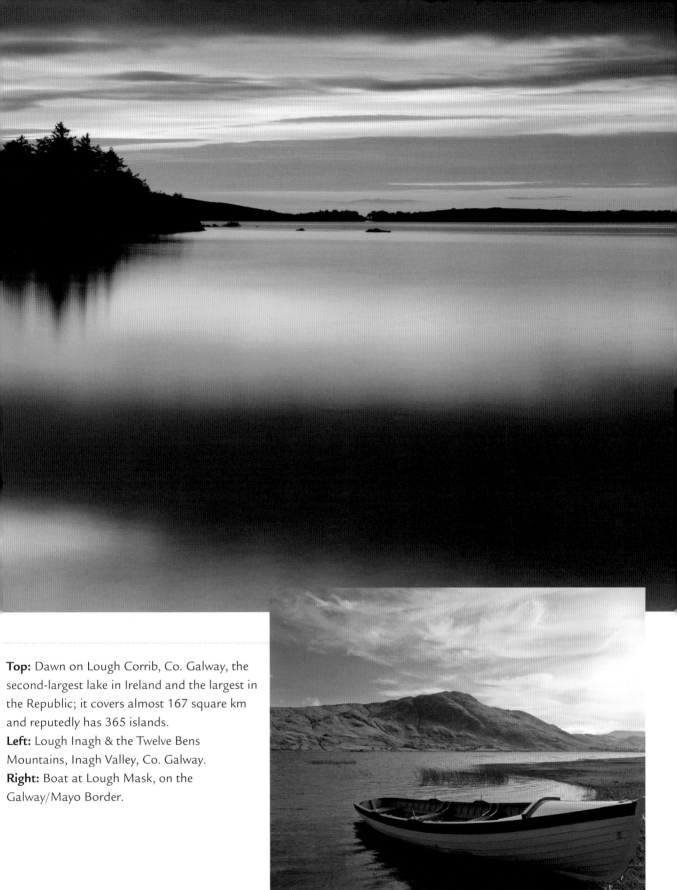

Top: Dawn on Lough Corrib, Co. Galway, the second-largest lake in Ireland and the largest in the Republic; it covers almost 167 square km and reputedly has 365 islands.
Left: Lough Inagh & the Twelve Bens Mountains, Inagh Valley, Co. Galway.
Right: Boat at Lough Mask, on the Galway/Mayo Border.

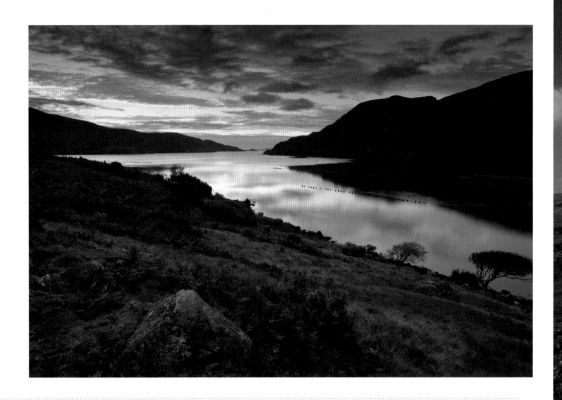

Above: Killary Harbour, Co. Galway is often called 'Ireland's only fjord'. It stretches for 16 km and reaches a depth of 45 metres.
Opposite top: Maumturk Mountains, Co. Galway
Below: Roundstone Bog Complex, Co. Galway is the biggest undamaged area of low-lying Atlantic Blanket Bog in Ireland and hosts a wealth of flora and fauna.
Opposite bottom: Ballyconneely Beach, Co. Galway.

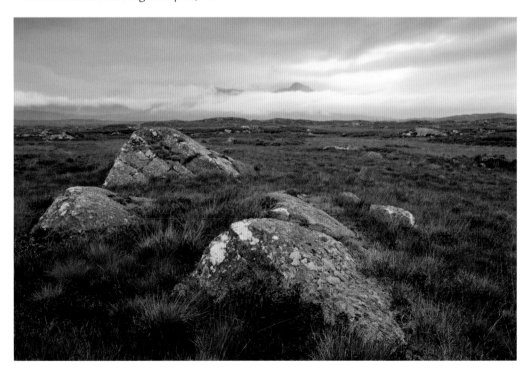

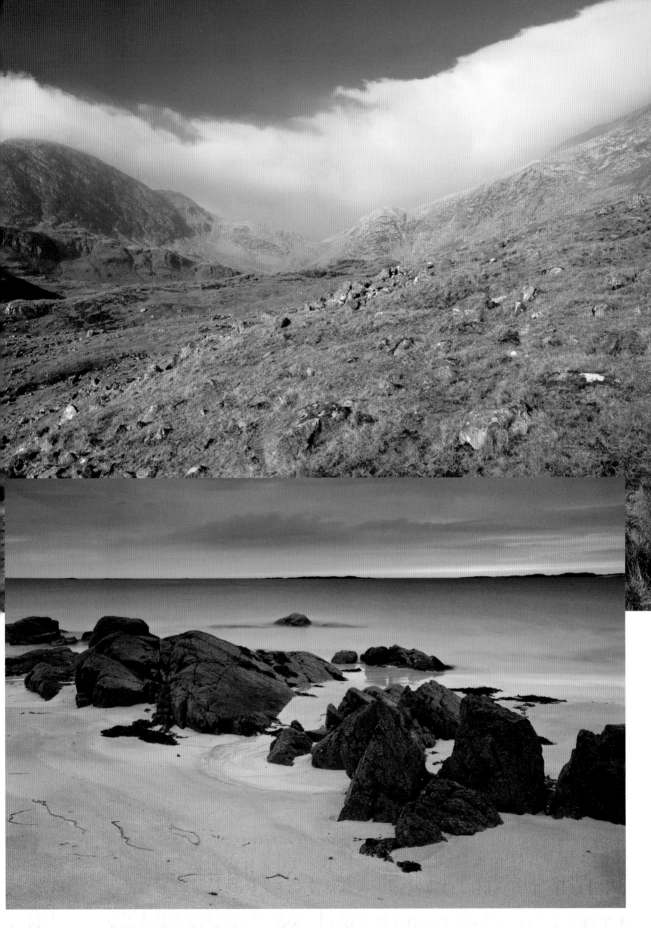

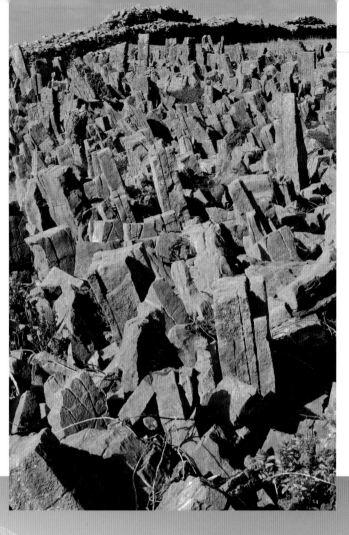

Left: Dun Aengus, Inis Mór, Co. Galway is a prehistoric stone fort on the largest of the Aran Islands. It is located on the edge of a 100m high cliff and its origin, function and history are largely unknown.

Below: Doo Lough Pass, Co. Mayo. Doo Lough was witness to tragedy during the Great Famine (1845-1849). A group of half-starved men, women and children were forced to undertake the journey from Louisburgh to Delphi to apply for famine relief. The 20 km journey over blanket bog in bad weather took its toll and legend has it that all of them died.

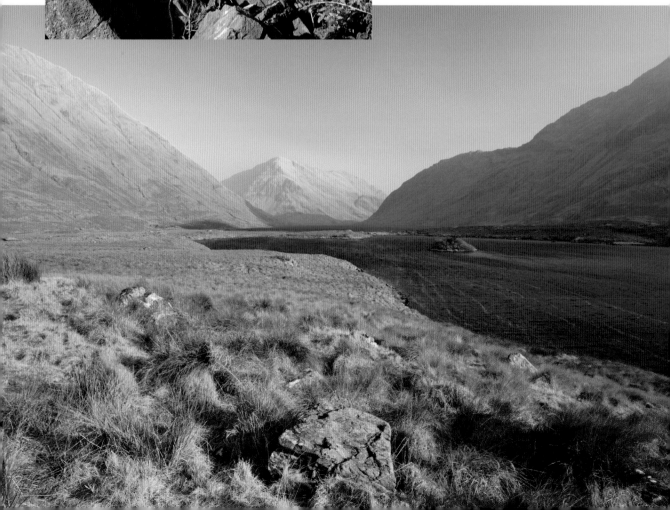

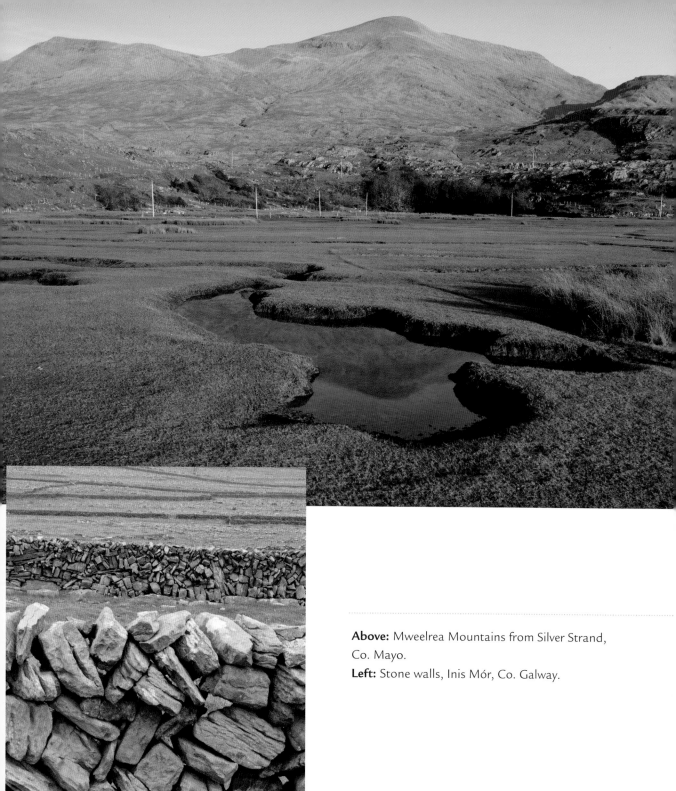

Above: Mweelrea Mountains from Silver Strand, Co. Mayo.
Left: Stone walls, Inis Mór, Co. Galway.

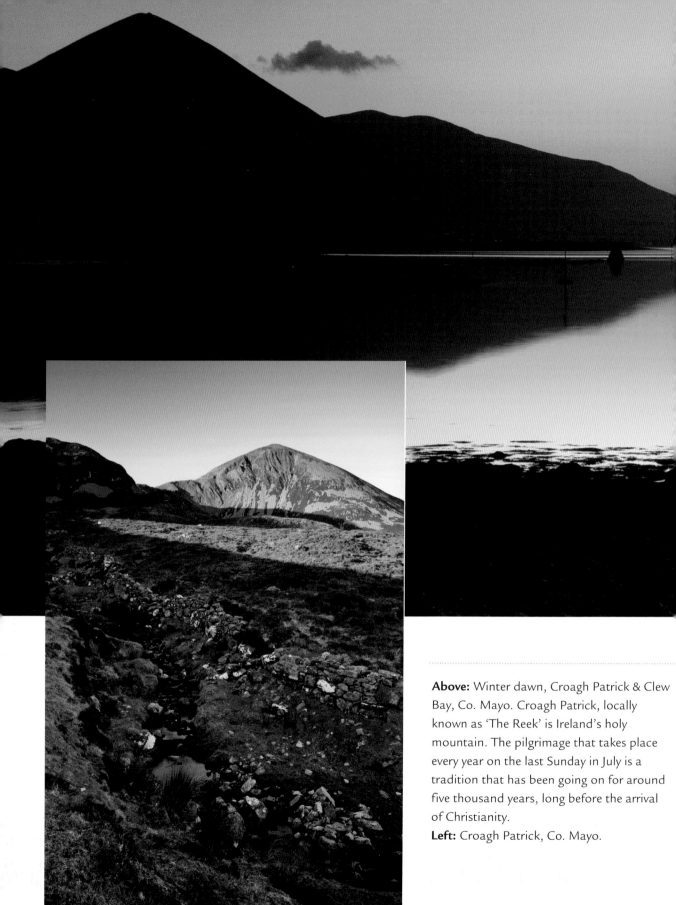

Above: Winter dawn, Croagh Patrick & Clew Bay, Co. Mayo. Croagh Patrick, locally known as 'The Reek' is Ireland's holy mountain. The pilgrimage that takes place every year on the last Sunday in July is a tradition that has been going on for around five thousand years, long before the arrival of Christianity.
Left: Croagh Patrick, Co. Mayo.

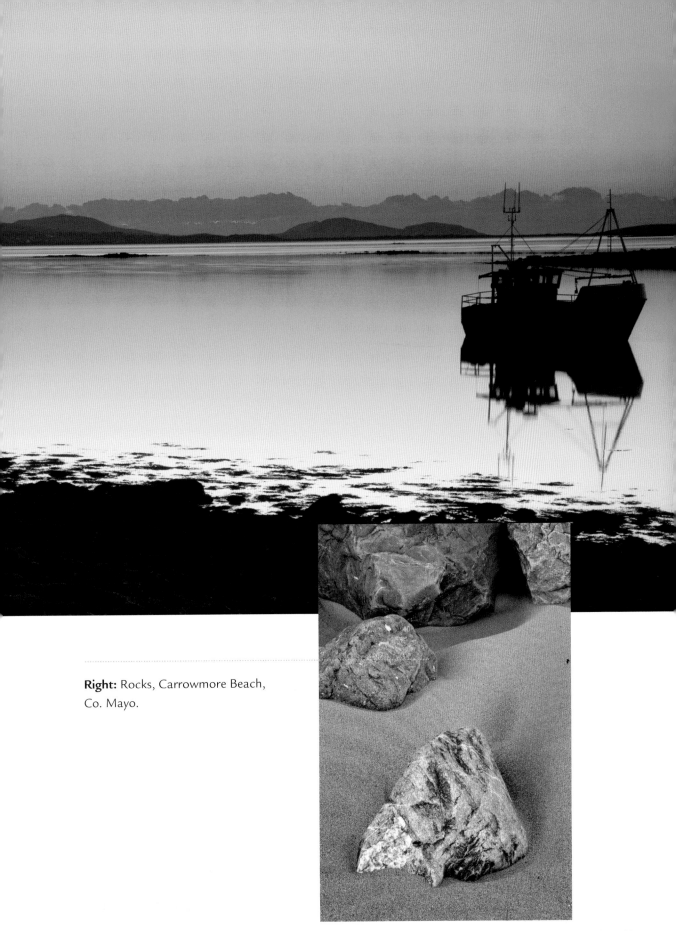

Right: Rocks, Carrowmore Beach, Co. Mayo.

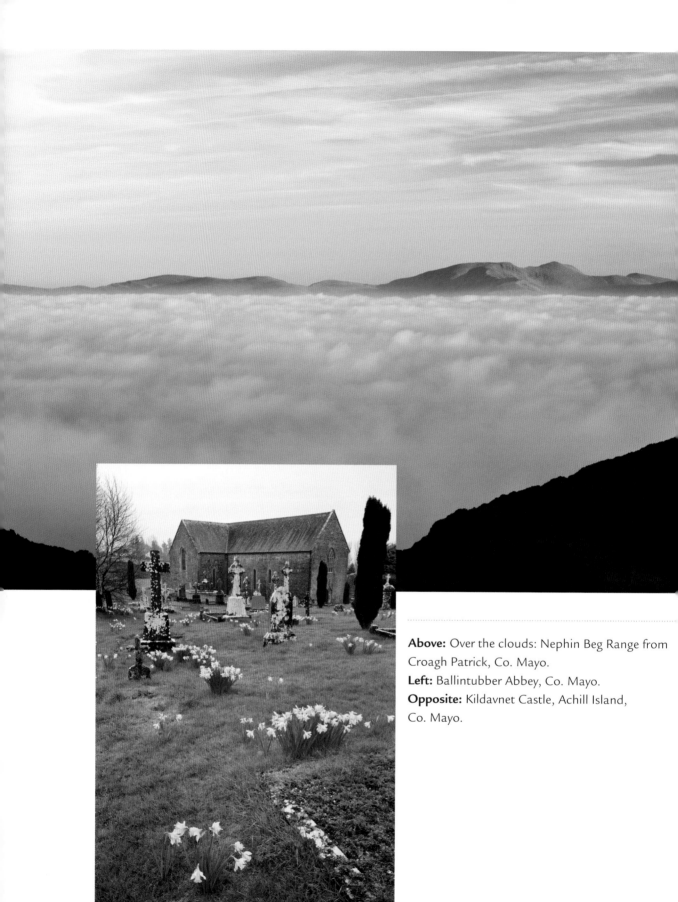

Above: Over the clouds: Nephin Beg Range from Croagh Patrick, Co. Mayo.
Left: Ballintubber Abbey, Co. Mayo.
Opposite: Kildavnet Castle, Achill Island, Co. Mayo.

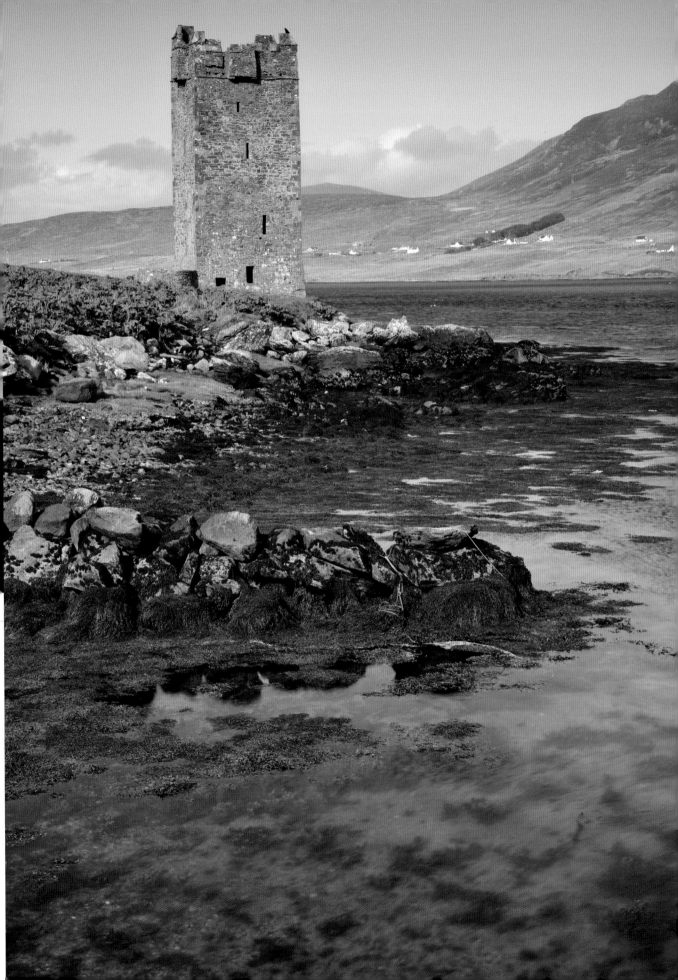

Left: Keem Strand, Achill Island, Co. Mayo. This is probably Ireland's most beautiful beach. A stretch of white sand framed by sheer cliffs and on a sunny day it can feel like being in the Caribbean.
Below: Autumn morning, Lough Conn, Co. Mayo.
Opposite: This deserted village, on Slievemore, Achill Island, Co. Mayo is a reminder of the Great Famine. The houses of the village stretch along the foot of Slievemore with most walls still intact and the shapes of the 'lazy beds', where potatoes were grown, still visible.

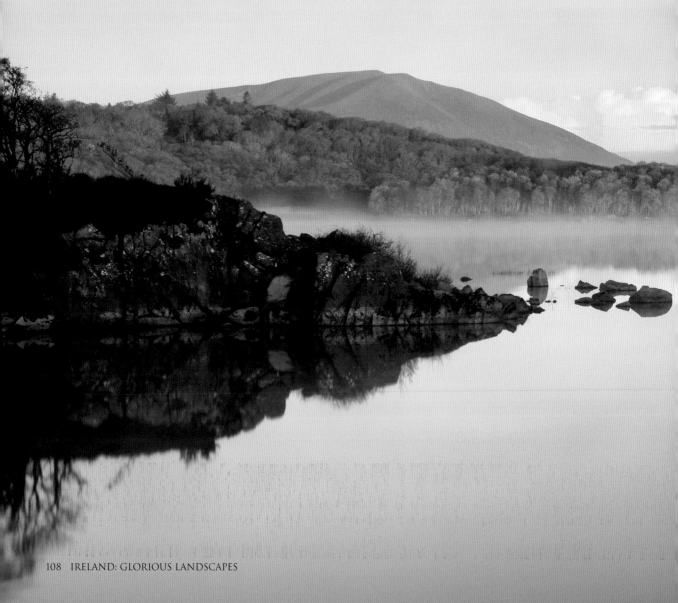

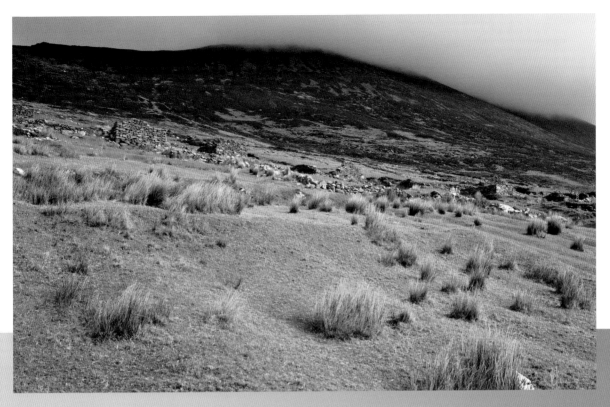

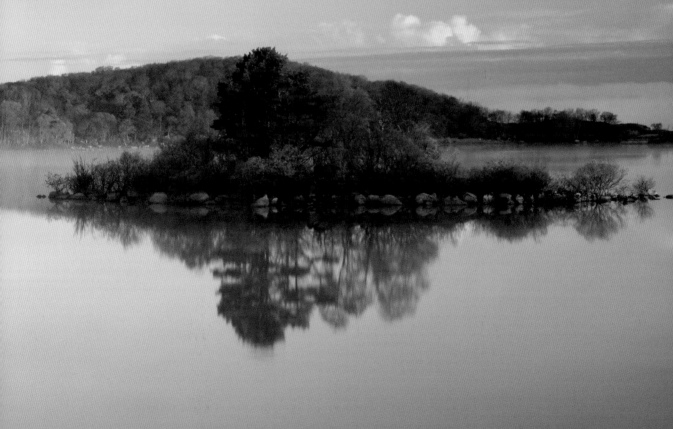

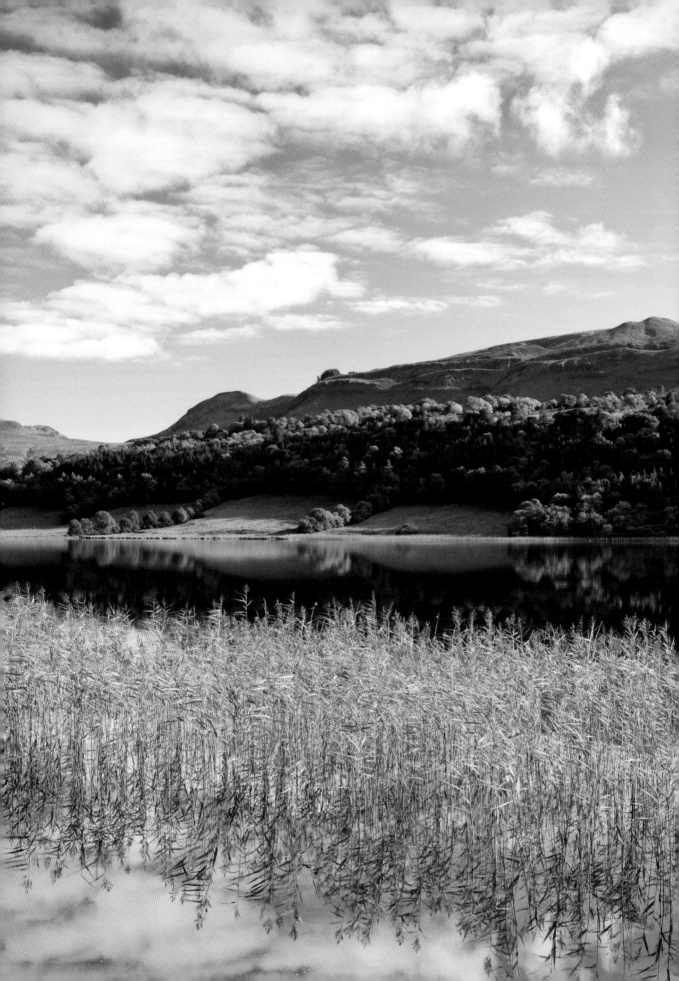

THE NORTH WEST

Hauntingly beautiful on sunny and misty days; inhospitable on wet windswept ones, particularly before the advent of cars and warm tour buses. The history of this part of the island is closely linked with the Great Irish Famine of the 1840s, when the potato crop failed. Records show that over a million people died, while more than two million emigrated, many of these dying from disease on the emigrant or coffin ships as they made their way to the States. The North West, as well as other remote regions of the country, was hit particularly hard.

Yet the beauty of the North West has and continues to inspire poets, painters and writers. It takes in the island of Tory, the Derryveagh Mountains, and Glenveagh Castle, now part of a national park. A hated landlord, Sir John Adair, who is reported to have evicted 244 tenants in the notorious Derryveagh Evictions of 1861, built this house. It and most of its contents and the grounds were subsequently donated to the state in 1983.

There are wonderful beaches, walks and climbs to be found in this region and you'll find many of the road and shop signs in Irish (Gaelic) as parts of Donegal have a large percentage of native speakers.

Opposite left: Glencar Lough, Co. Sligo. Glencar is the best known of the Leitrim Glens. The area is closely associated with the poet W. B. Yeats who lies buried in nearby Drumcliff.

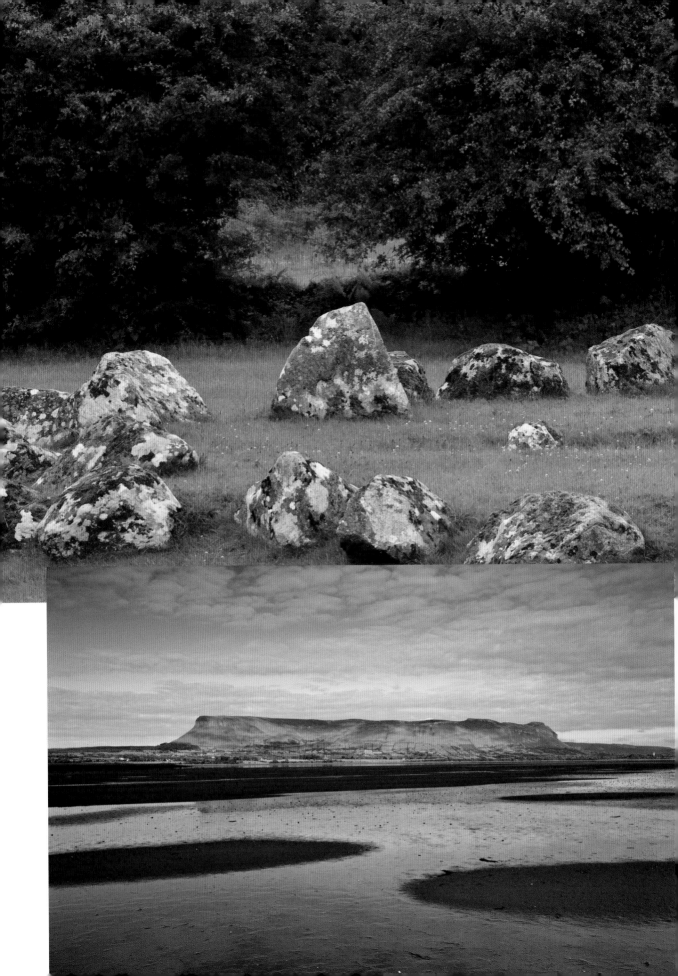

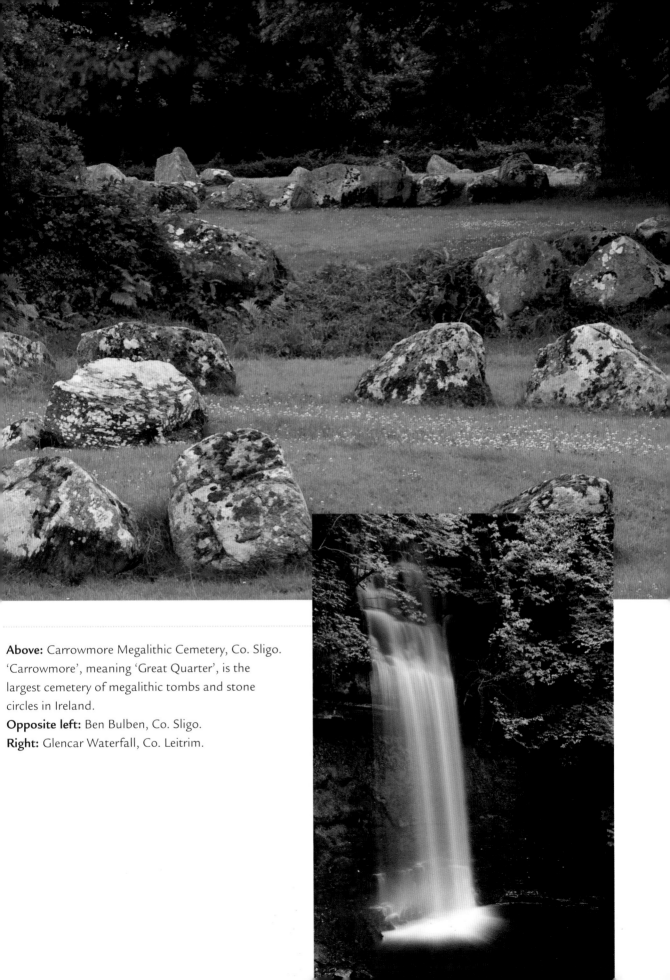

Above: Carrowmore Megalithic Cemetery, Co. Sligo. 'Carrowmore', meaning 'Great Quarter', is the largest cemetery of megalithic tombs and stone circles in Ireland.
Opposite left: Ben Bulben, Co. Sligo.
Right: Glencar Waterfall, Co. Leitrim.

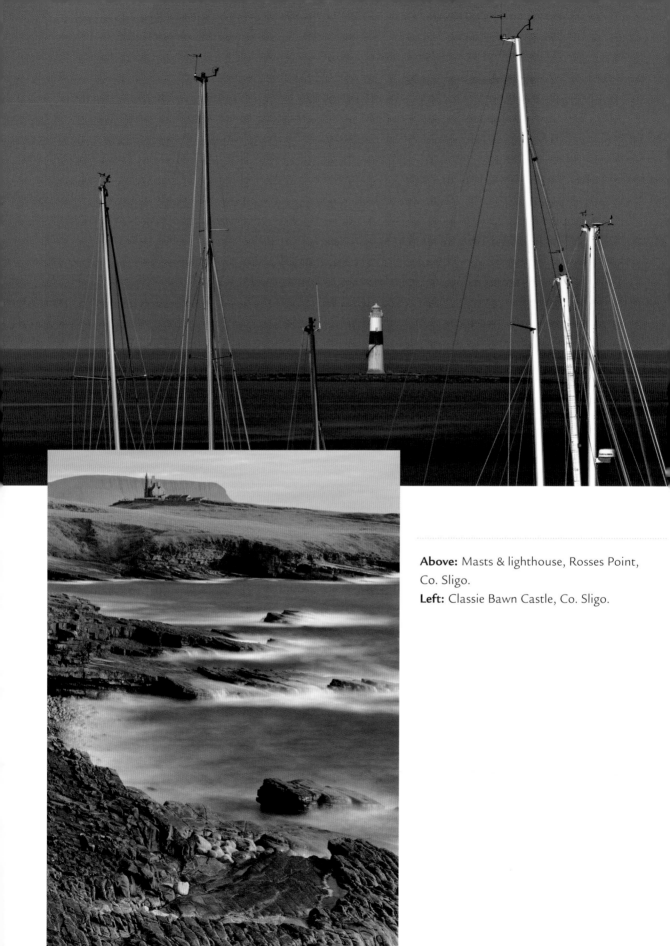

Above: Masts & lighthouse, Rosses Point, Co. Sligo.
Left: Classie Bawn Castle, Co. Sligo.

Right: Maeve's Cairn, Knocknarea, Co. Sligo. Knocknarea is one of Sligo's landmarks. The prominent mountain is crowned by one of Ireland's largest cairns, supposedly the burial place of Maeve, the mythological queen of Connaught.

Below: Lough Easkey, Co. Sligo.

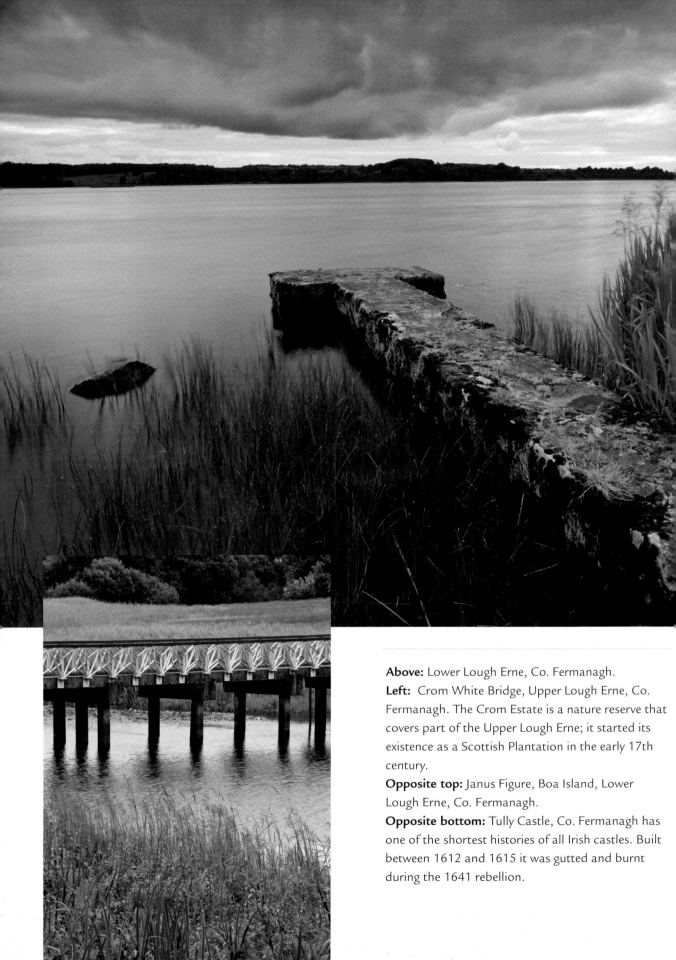

Above: Lower Lough Erne, Co. Fermanagh.
Left: Crom White Bridge, Upper Lough Erne, Co. Fermanagh. The Crom Estate is a nature reserve that covers part of the Upper Lough Erne; it started its existence as a Scottish Plantation in the early 17th century.
Opposite top: Janus Figure, Boa Island, Lower Lough Erne, Co. Fermanagh.
Opposite bottom: Tully Castle, Co. Fermanagh has one of the shortest histories of all Irish castles. Built between 1612 and 1615 it was gutted and burnt during the 1641 rebellion.

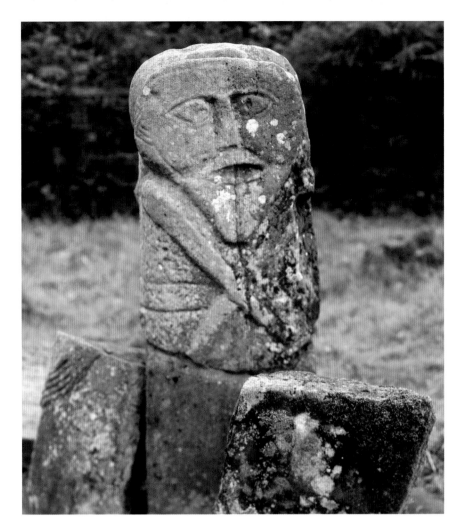

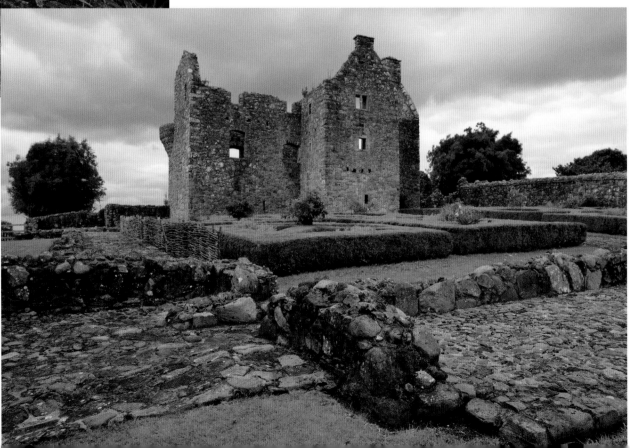

Left: Cuilcagh Mountains, Co. Fermanagh.

Below: Slieve League mountain range, Co. Donegal, features Ireland's second-highest, very impressive, sea cliffs.

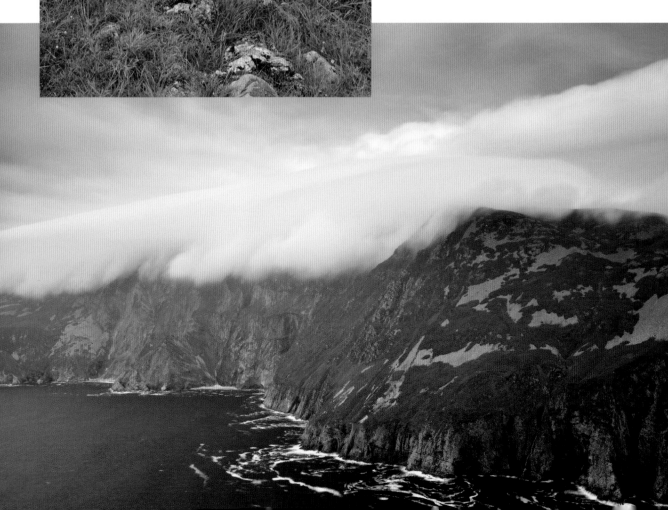

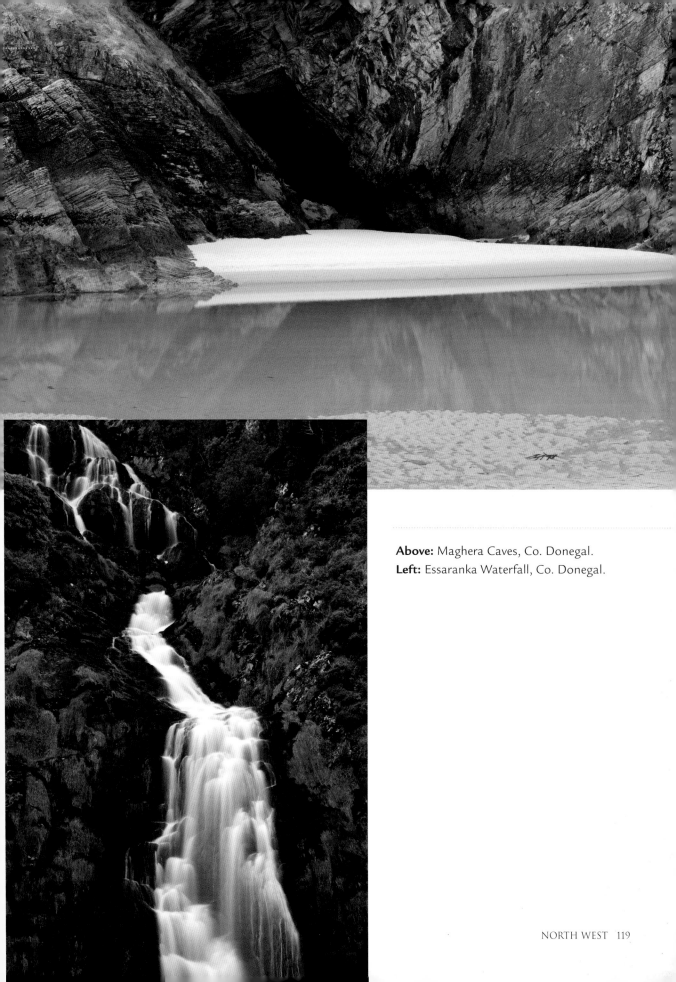

Above: Maghera Caves, Co. Donegal.
Left: Essaranka Waterfall, Co. Donegal.

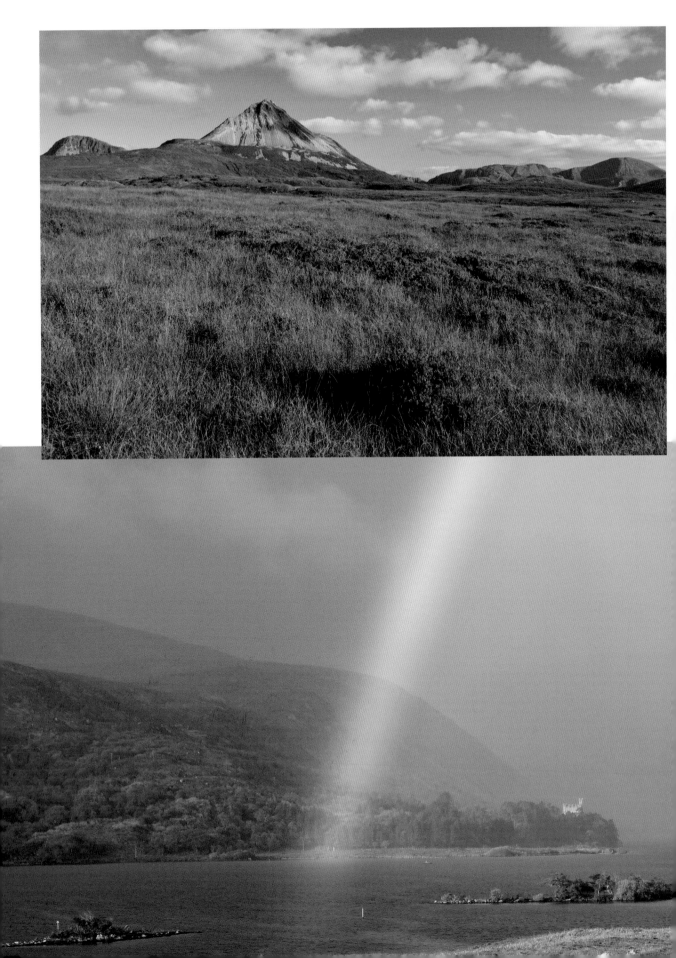

Opposite left: Errigal Mountain & Derryveagh Mountains, Co. Donegal. Errigal Mountain is Donegal's highest and Ulster's second highest summit and a landmark that can be seen from all directions.
Right: Dunlewy Church & Errigal Mountain in clouds, Co. Donegal
Below: Rainbow, Glenveagh National Park, Co. Donegal. Glenveagh is Ireland's biggest national park and covers the main part of the Derryveagh Mountains. The shores of Lough Veagh feature a castle and gardens.

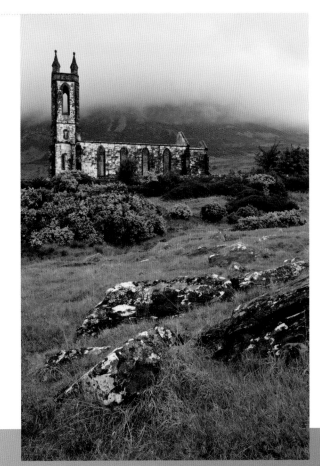

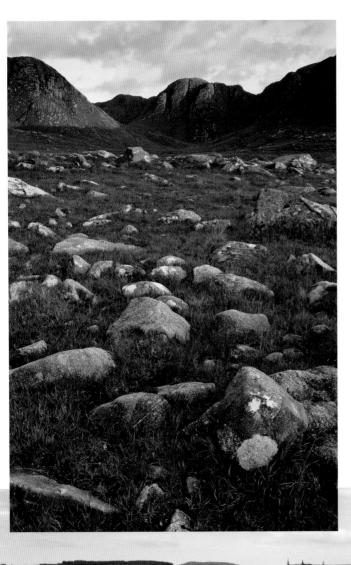

Left: Poison Glen, Co. Donegal.
Below: Lough Derg & Station Island, Co. Donegal. Station Island on Lough Derg has been one of Europe's most important places for pilgrimage and retreat since the 12th century.

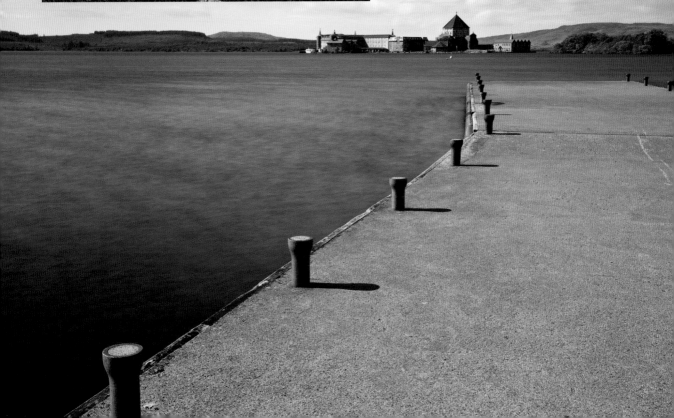

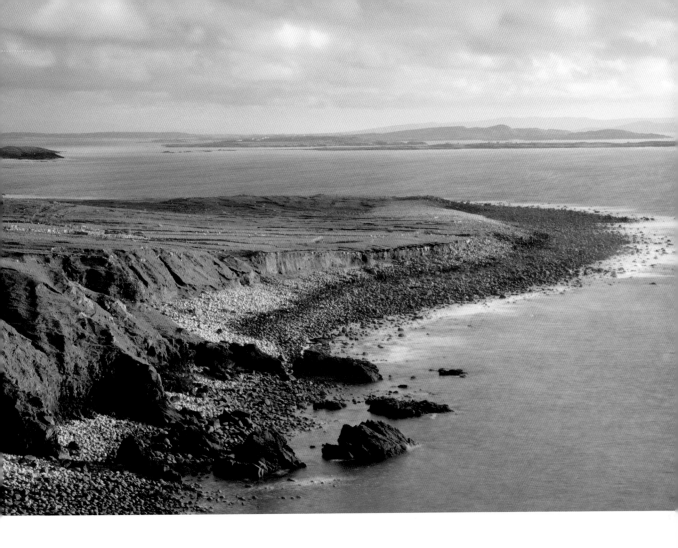

Above: Bloody Foreland, Co. Donegal.
Right: Boats & lobster pots, Arranmore Island, Co. Donegal.

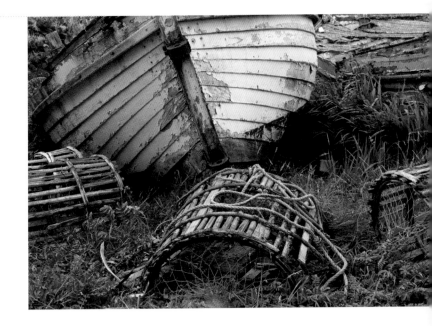

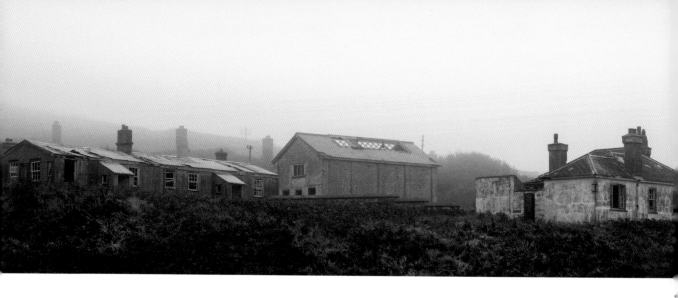

Above: Fort Dunree, Inishowen, Co. Donegal. The Inishowen Peninsula features Ireland's most northerly point and is bordered by two sea loughs, Lough Swilly to the west and Lough Foyle to the east. Lough Swilly has long been an invasion point, first for Vikings and later for Anglo-Normans. The English built Fort Dunree in the late 18th century fearing a French invasion; it was still in use during World War I and World War II. Today, it houses a military museum.

Below: Buncrana at dusk, Inishowen, Co. Donegal.

Opposite top: Arranmore Lighthouse, Arranmore Island, Co. Donegal.

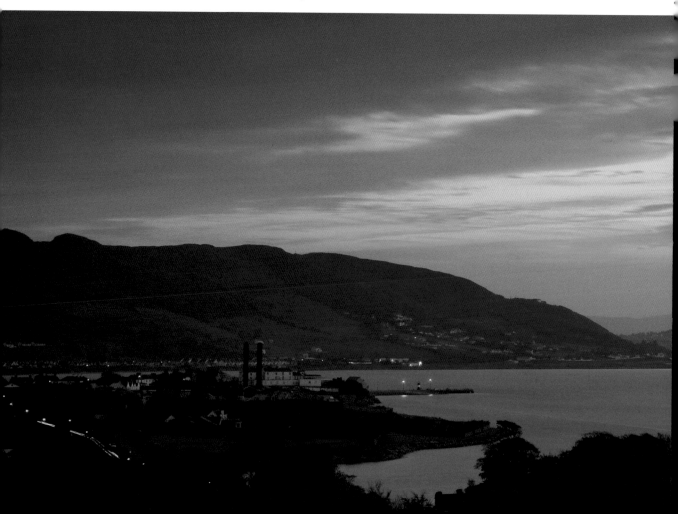

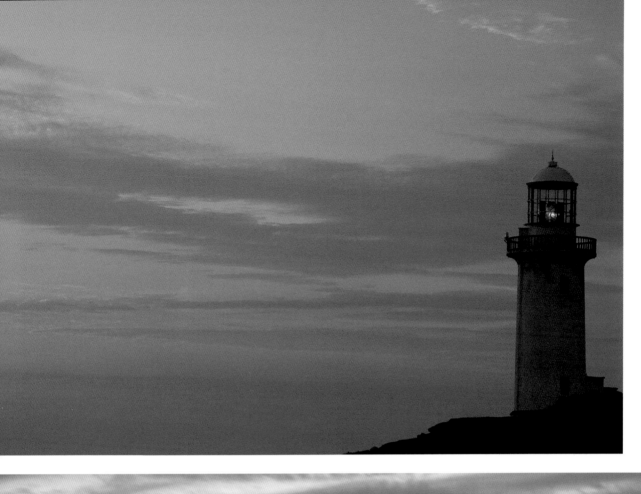

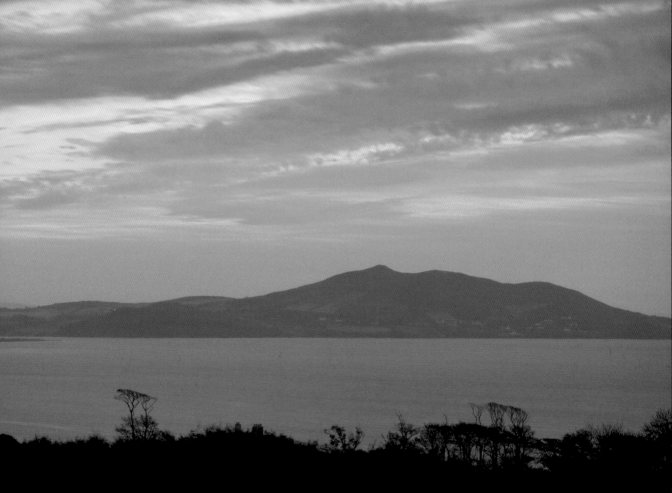

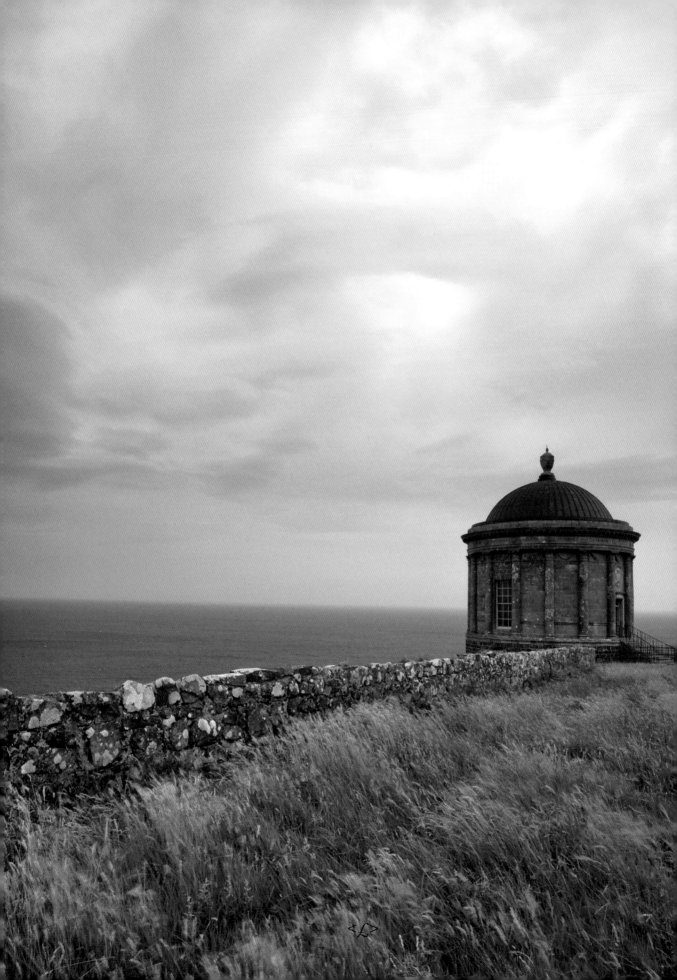

THE NORTH EAST

his region takes in five out of the six counties that make up Northern Ireland and the spectacular Antrim coastline right around to the Mourne Mountains and inland to Lough Neagh.

Belfast is its capital, home of the famous Harland and Wolfe shipbuilding yards where the Titanic was built and where the giant cranes, known locally as 'Goliath and Samson' still dominate the dockland sky.

The coastline is dotted with resorts where families used to go for summer holidays before overseas package deals and discount air fares. However, the Giant's Causeway is perhaps the most famous spot on the coastal tour. This phenomenon is made of some 40,000 interlocking basalt columns, the remains of a volcano eons ago. These columns form stepping stones that lead into the sea, thus giving way to legends of giants using them to walk across to Scotland.

Armagh is the oldest city and the ecclesiastical capital of all Ireland. It is guarded by two cathedrals, both dedicated to Saint Patrick. The older Protestant one dates back to medieval times and it is here that the last High King of Ireland, Brian Boru, is buried. He is credited with ridding the Irish of the Vikings in 1014.

Opposite left: The Mussenden Temple, Co. Derry, part of the Downhill Estate and built in 1785, was modelled on the Temple of Vesta in Italy and used as a library. Constant cliff erosion now threatens the building.

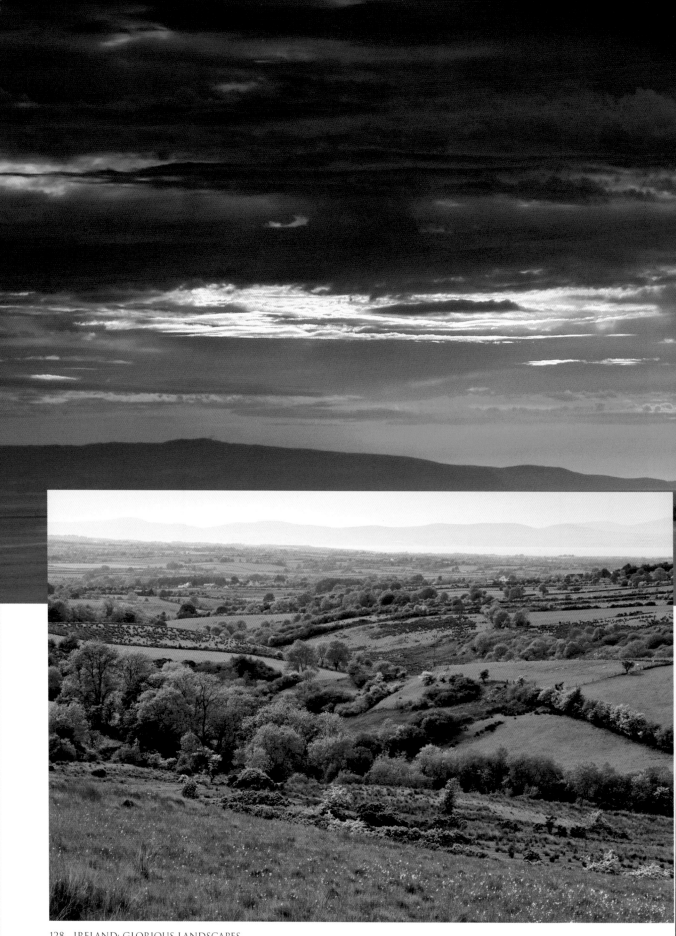

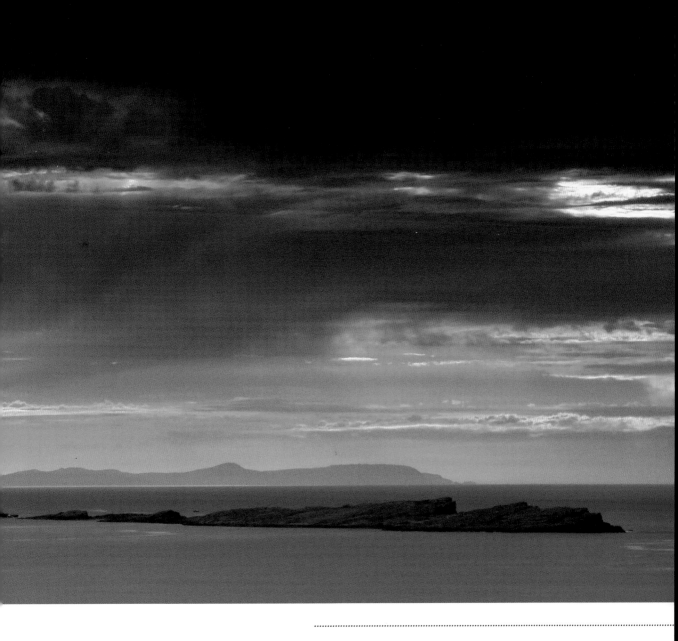

Above: Inishowen, Co. Derry.
Opposite left: Sperrin Mountains, Co. Derry are the largest mountain range in Northern Ireland; 'Sperrin' means 'spurs of rock'.

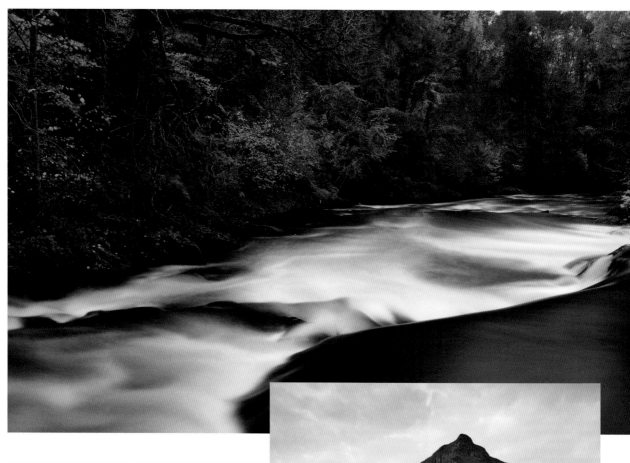

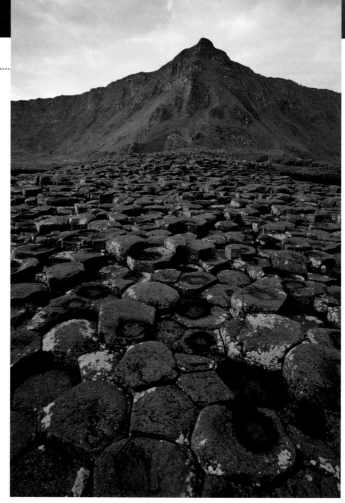

Above: Autumn at Roe Valley, Co. Derry. The River Roe has cut a deep glen into the landscape; its valley was the centre for a thriving flax industry and saw one of the first hydroelectric plants in Ireland.

Right: Giant's Causeway looking south, Co. Antrim.

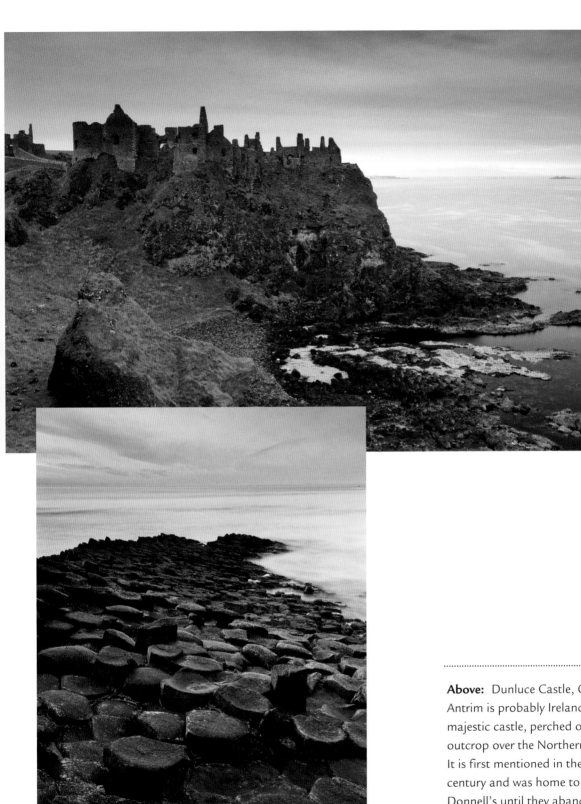

Above: Dunluce Castle, Co. Antrim is probably Ireland's most majestic castle, perched on a rock outcrop over the Northern Atlantic. It is first mentioned in the 14th century and was home to the Mc-Donnell's until they abandoned it in 1690.

Left: Giant's Causeway looking north, Co. Antrim.

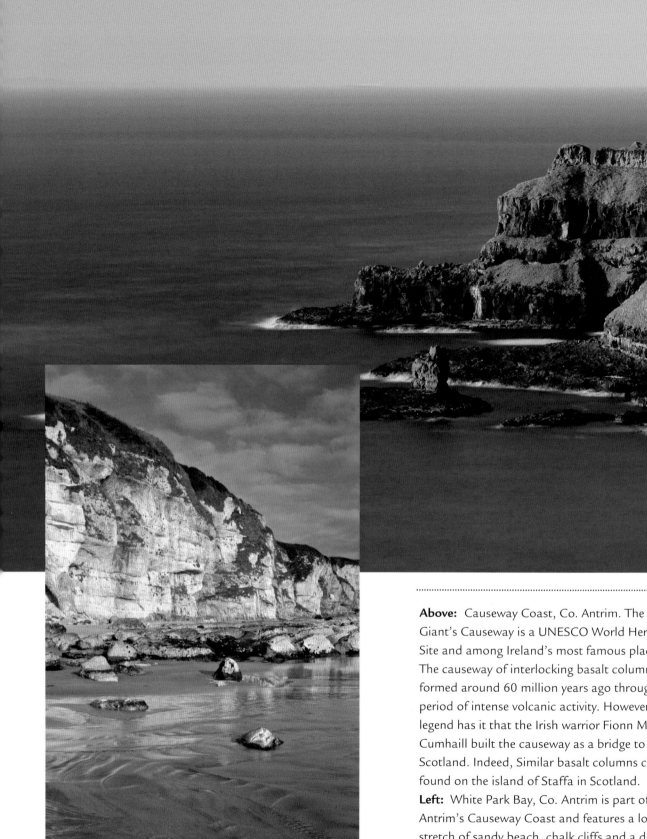

Above: Causeway Coast, Co. Antrim. The Giant's Causeway is a UNESCO World Heritage Site and among Ireland's most famous places. The causeway of interlocking basalt columns wa formed around 60 million years ago through a period of intense volcanic activity. However, legend has it that the Irish warrior Fionn Mac-Cumhaill built the causeway as a bridge to Scotland. Indeed, Similar basalt columns can be found on the island of Staffa in Scotland.

Left: White Park Bay, Co. Antrim is part of Antrim's Causeway Coast and features a long stretch of sandy beach, chalk cliffs and a dune system with a unique flora.

Right: Cottage & tree, Glenariff, Co. Antrim.

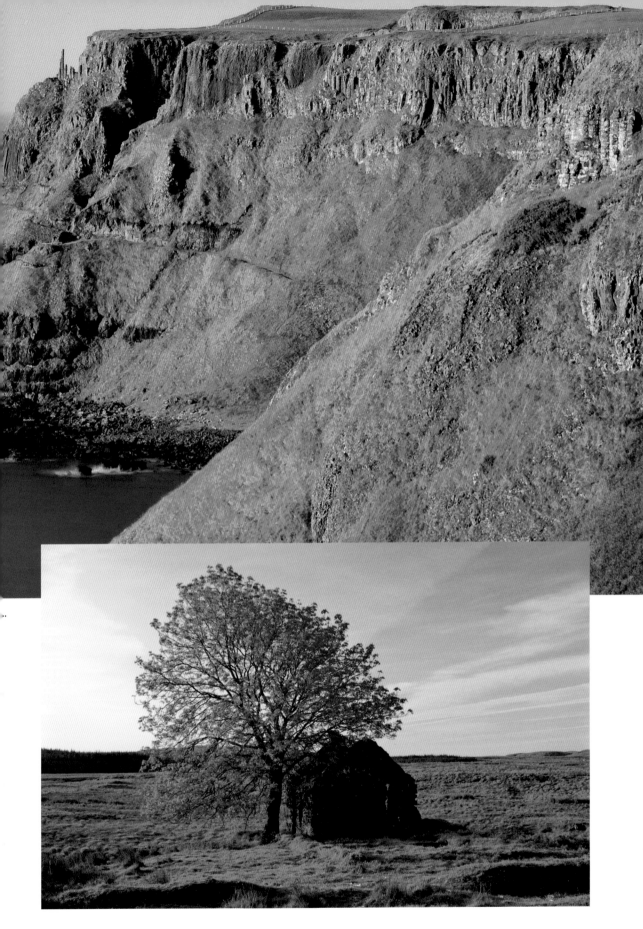

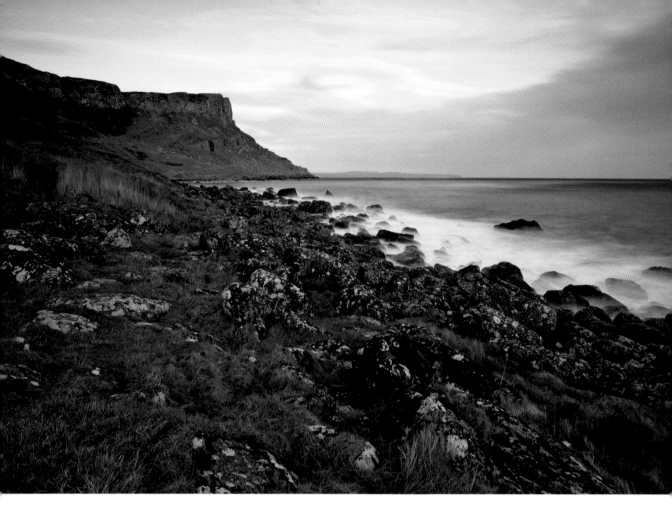

Above: Fair Head from Murlough Bay, Co. Antrim.
Below: Carnlough Harbour, Co. Antrim.

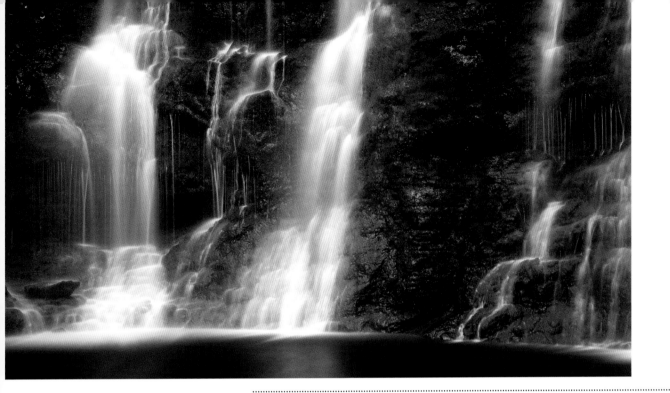

Above: Waterfall, Glenariff, Co. Antrim.
Below: Glenariff, Co. Antrim is one of the Nine Glens of
Antrim. Like all the Antrim glens the 'Queen of Glens',
as it is often called, was shaped during the last ice age
by glaciers cutting in the landscape.

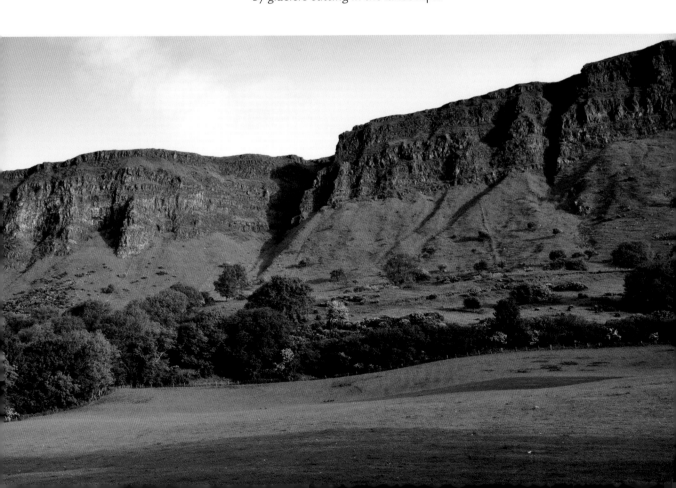

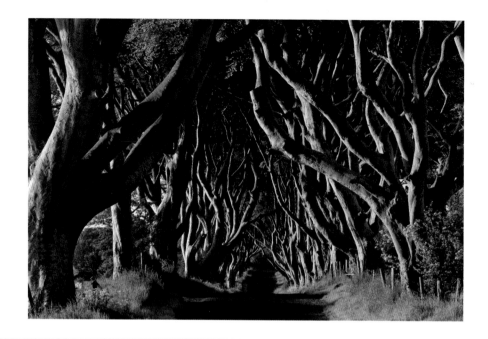

Above: Dark hedges, near Stranocum, Co. Antrim. This avenue of trees is thought to be 300 years old and is reputedly haunted by a 'grey lady'.

Opposite top: Lough Neagh, Ardboe, Co. Tyrone. Lough Neagh is not only Ireland's largest lake, but also the largest freshwater body on the British Islands. It covers almost 400 square km and legend has it that it – like the Giant's Causeway – was created by Fionn MacCumhaill who scooped out a portion of earth and tossed it at an enemy. He missed – the chunk of earth became the Isle of Man and the hole it left behind became Lough Neagh.

Below: Standing on the northern shores of Lough Neagh, Co. Antrim, Cranfield Church, with its interesting graveyard and headstones (**below right**), dates back to 1306.

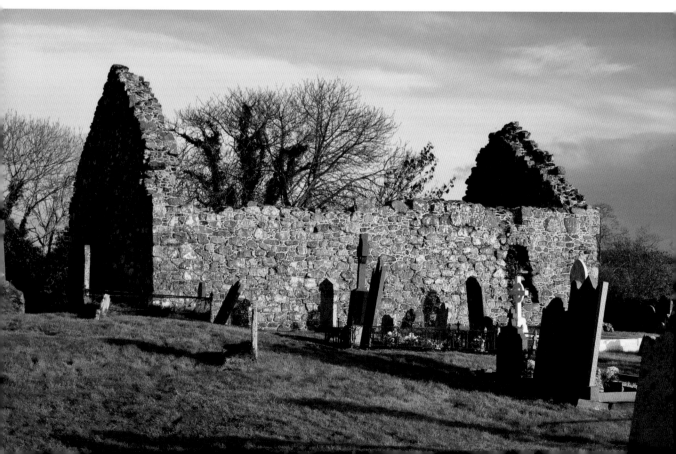

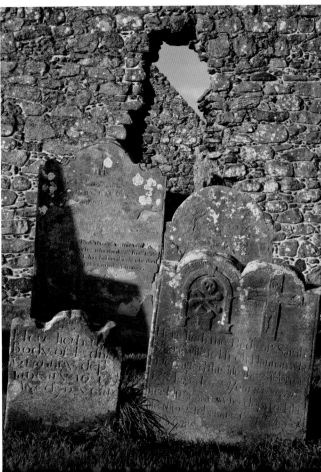

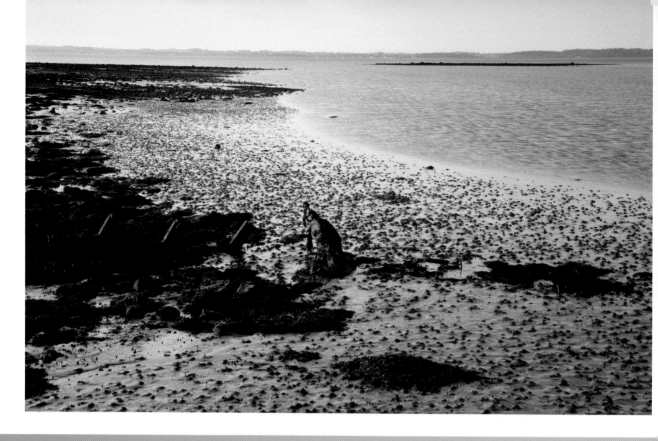

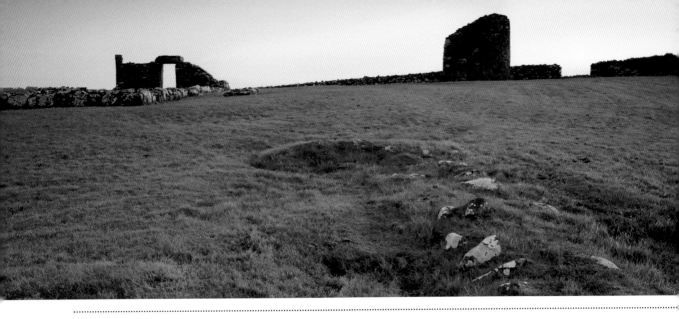

Opposite top: Strangford Lough, Mahee Island, Co. Down.
Below: Donaghadee Harbour, Co. Down.

Top: Nendrum Monastery, Co. Down was an early Christian monastery on Mahee Island. Probably founded in the 5th century, it lasted for around 500 years until it almost certainly fell victim to a Viking raid.

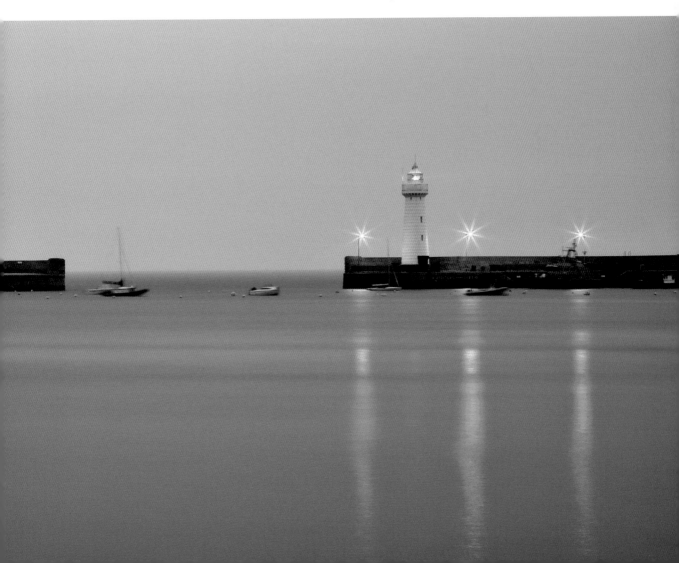

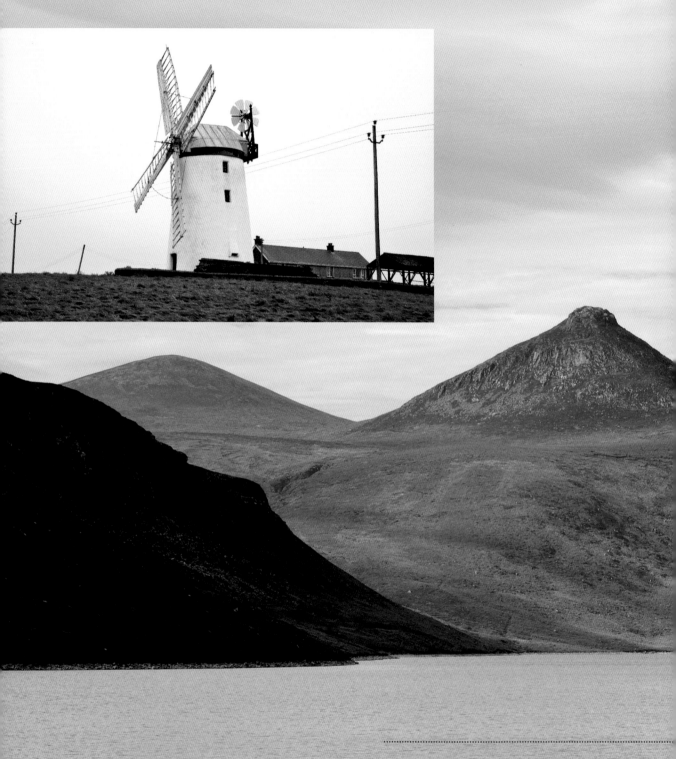

Main picture: Silent Valley, Mourne Mountains, Co.
Down. The Silent Valley is part of the famous
Mourne Mountains. Its reservoir, finished in 1933,
provides water for Co. Down and parts of Belfast.
Inset top: Ballycopeland Windmill, Co. Down.
Inset opposite: Murlough Nature Reserve & Mourne
Mountains in clouds, Co. Down.

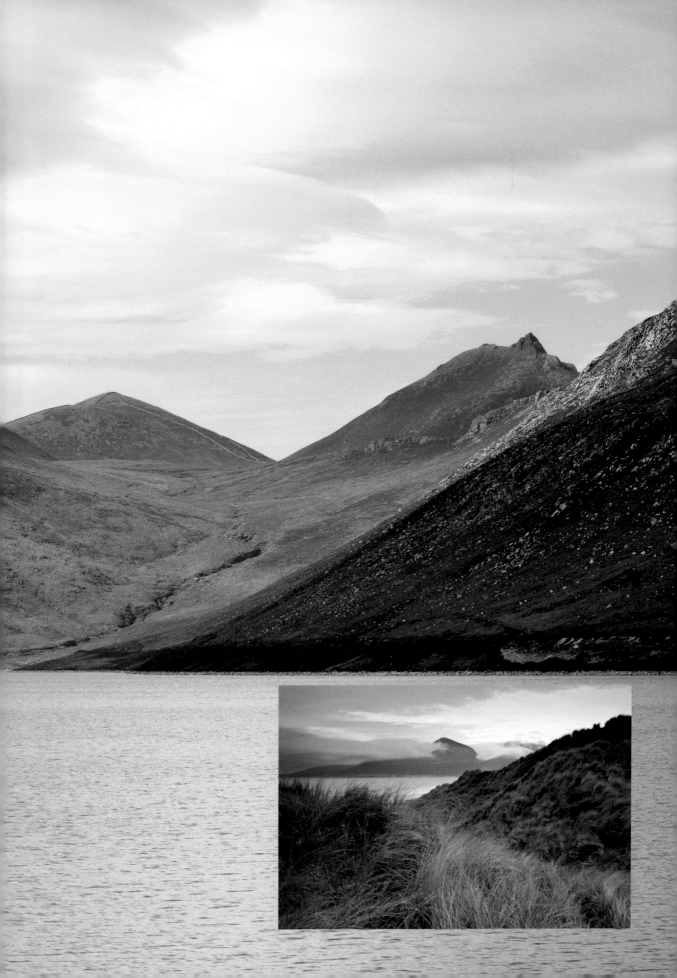

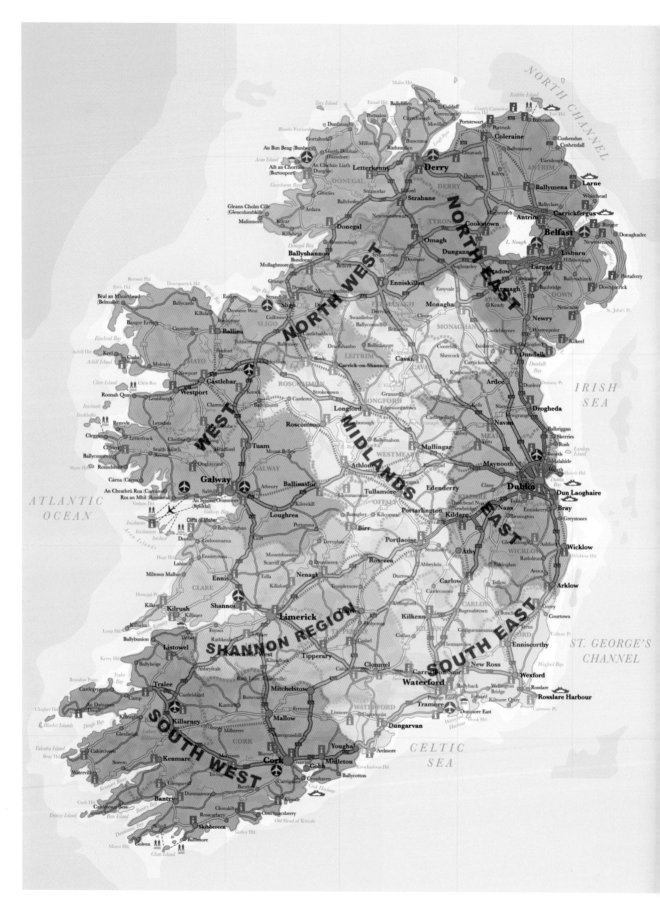

IRELAND

EAST:

Kildare, Meath, Dublin, Wicklow, Louth

SOUTH EAST:

Waterford, Wexford, Kilkenny, Carlow

SOUTH WEST:

Kerry, Cork

SHANNON REGION:

Clare, Limerick, Tipperary

MIDLANDS:

Monaghan, Cavan, Longford,

Roscommon, Westmeath, Offaly, Laois

WEST:

Galway, Mayo

NORTH WEST:

Donegal, Fermanagh, Leitrim, Sligo

NORTH EAST:

Derry, Antrim, Tyrone, Armagh, Down

Motorways		Coastal Sandy Beach
Motorways (under construction)		Airports
National Primary Routes		International Car Ferry
National Secondary Routes		Local Car / Passenger Ferry
Other Routes (selected)		Tourist Information Offices
Railways		(all year)
County Boundary		Tourist Information Offices
Northern Ireland Border		(seasonal)

First published 2010 by The O'Brien Press Ltd,
12 Terenure Road East, Rathgar, Dublin 6, Ireland.
Tel: +353 1 4923333; Fax: +353 1 4922777
E-mail: books@obrien.ie
Website: www.obrien.ie
Reprinted 2012.

ISBN: 978-1-84717-146-7

A catalogue record of this title is available from The British Library

2 3 4 5 6 7 8 9 10
12 13 14 15 16

Printed and bound in Poland by Białostockie Zakłady Graficzne S.A.
The paper used in this book is produced using pulp from managed forests.